+AOCMYS99
8.95

Cat. No. 23-221

An Anthology of
CHRISTIAN
MYSTICISM

Edited with biographical notes
by Paul De Jaegher

Translated by
Donald Attwater and others

 TEMPLEGATE PUBLISHERS
Springfield, Illinois

First published by
Burns and Oates Limited
2-10 Jerdan Place
London SW6 5PT
England

©1977 by Burns and Oates Limited

Published in the United States of America by
Templegate Publishers
302 East Adams, P.O. Box 963
Springfield, Illinois 62705

ISBN 0-87243-073-1

CONTENTS

v

CONTENTS

BLESSED JOHN RUYSBROECK

1293-1381

JOHN RUYSBROECK, called 'the Admirable,' was born at
Ruysbroeck, near Brussels, in the year 1293. When he
was eleven he was put in charge of his uncle, John
Hinckaert, a canon of the collegiate church of St. Gudule
at Brussels, who educated him. In 1317, he was ordained
priest and given a chaplaincy at St. Gudule's, but John
found the city very distracting and eventually, in 1343,
together with his uncle, Francis van Coudenberg, and the
holy John of Afflighem, he withdrew to a lonely valley
in the forest of Soignies, called Groenendael ('the green
vale'). Seven years later they all took the habit of the
canons regular of St. Augustine.

At Groenendael, Ruysbroeck gave himself entirely to
contemplation. From time to time he would go into
the forest to write down his reflections ; later on, he was
accompanied by a lay-brother, to whom he dictated. He
became known far and wide ; among his distinguished
visitors were Tauler and Gerard Groot, who was prior of
a neighbouring charterhouse.

Ruysbroeck died in 1381 at the age of eighty-eight,
after a life of the highest contemplation and mystical
union with God. In 1908, his immemorial *cultus* was
confirmed by the Holy See, and his feast is observed by the
Augustinian canons regular.

Blessed John wrote in the Brabant dialect of Flemish,
in order that he might be more widely read and under-
stood. He teaches that the soul can attain Divine union
only by the way of complete renunciation and the dis-
carding of all sensible images. Her most powerful help
comes from the gifts of the Holy Ghost, which enlighten,
cleanse, beautify, and nourish the soul as the sun does
the earth.

Ruysbroeck is unquestionably one of the greatest contemplatives, and with such as Hadewyck, Sister Beatrice of Nazareth, and the unknown author of *The Pearl*, helped Flemish mysticism to reach so high a standard in the thirteenth and fourteenth centuries. From the psychological point of view Ruysbroeck has been bettered, but from the ontological he is incomparable, a very eagle. He has been appreciated as much by his successors as by his contemporaries ; Denis, the Carthusian, calls him a ' divine teacher,' and Bossuet regarded him as the most famous and the master of all the mystics of his time.

TRANSLATIONS : *The Sparkling Stone* (London, Dent, 1916). *The Adornment of the Spiritual Marriage* (Dent).

The best French translation of Ruysbroeck's writings is that of the Benedictines of Wisques (Paris, 5 vols.).

WATCH THE BEE

BY means of a comparison Ruysbroeck shows that we must depend not on the sweetness of Divine consolation, but on God Himself.

Now I will give you a short similitude, that you may not err in this case, but may govern yourselves prudently. You should watch the wise bee and do as it does. It dwells in unity, in the congregation of its fellows, and goes forth, not in the storm, but in calm and still weather, in the sunshine, towards all those flowers in which sweetness may be found. It does not rest on any flower, neither on any beauty nor on any sweetness ; but it draws from them honey and wax, that is to say, sweetness and light-giving matter, and brings both to the unity of the hive, that therewith it may produce fruits, and be greatly profitable.

Christ, the Eternal Son, shining into the open heart, causes that heart to grow and to bloom, and it overflows with all the inward powers with joy and sweetness.

So the wise man will do like the bee, and he will

fly forth with attention and with reason and with
discretion, towards all those gifts and towards all that
sweetness which he has experienced, and towards all
the good which God has ever done to him. And in
the light of love and with inward observation, he will
taste of the multitude of consolations and good things ;
and will not rest upon any flower of the gifts of God,
but, laden with gratitude and praise, will fly back
into the unity, wherein he wishes to rest and to dwell
eternally with God.

THE DIVINE SON IN THE VALE
OF THE SOUL

Now understand this : when the sun sends its beams
and its radiance into a deep valley between two high
mountains, and, standing in the zenith, can yet shine
upon the bottom and ground of the valley, then three
things happen : the valley becomes full of light by
reflection from the mountains, and it receives more
heat, and becomes more fruitful, than the plain and
level country. And so likewise, when a good man
takes his stand upon his own littleness, in the most
lowly part of himself, and confesses and knows that
he has nothing, and is nothing, and can do nothing of
himself, neither stand still nor go on, and when he
sees how often he fails in virtues and good works :
then he confesses his poverty and his helplessness,
then he makes a valley of humility. And when he is
thus humble, and needy, and knows his own need ;
he lays his distress, and complains of it, before the
bounty and the mercy of God. And so he marks the
sublimity of God and his own lowliness ; and thus
he becomes a deep valley. And Christ is a Sun of
righteousness and also of mercy, Who stands in the
highest part of the firmament, that is, on the right
hand of the Father, and from thence He shines into the

bottom of the humble heart ; for Christ is always
moved by helplessness, whenever a man complains
of it and lays it before Him with humility. Then
there arise two mountains, that is, two desires ; one
to serve God and praise Him with reverence, the
other to attain noble virtues. Those two mountains
are higher than the heavens, for these longings touch
God without intermediary, and crave His ungrudging
generosity. And then that generosity cannot withhold
itself, it must flow forth ; for then the soul is made
ready to receive, and to hold, more gifts.

These are the wherefore, and the way of the new
coming with new virtues. Then, this valley, the
humble heart, receives three things : it becomes more
radiant and enlightened by grace, it becomes more
ardent in charity, and it becomes more fruitful in
perfect virtues and in good works.

THE INSATIABLE HUNGER FOR GOD

THE more the generous soul glimpses God, the greater
is her hunger and thirst for Him. This is the grace
which Ruysbroeck describes in the following lines :

Here there begins an eternal hunger, which shall
never more be satisfied ; it is an inward craving and
hankering for the loving power and the created spirit
after an uncreated Good. And since the spirit longs
for fruition, and is invited and urged thereto by God,
it must always desire its fulfilment. Behold, now
there begins an eternal craving and continual yearning
in eternal insatiableness. All such are the poorest
of all men living ; for they are avid and greedy,
and their hunger is insatiable. Whatever they eat
or drink, they shall never be satisfied, for this hunger
is eternal. For a created vessel cannot contain an
uncreated Good : and hence there is here an eternal,
hungry craving without satisfaction, and God poured

forth above all and yet staying it not. Here are great dishes of food and drink, of which no one knows save he who tastes them : but full satisfaction in fruition is the dish which is lacking there, and therefore this hunger is ever renewed. Yet, in the touch, rivers of honey, full of all delights, flow forth ; for the spirit tastes these riches in all the ways which it can conceive and apprehend ; but all this is in a creaturely way and below God, and hence there remains an eternal hunger and impatience. Though God gave to such a man all the gifts which are possessed by all the saints, and everything that He is able to give, but withheld Himself, the gaping desire of the spirit would remain hungry and unsatisfied. The inward stirring and touching of God makes us hungry and yearning ; for the Spirit of God hunts our spirit ; and the more it touches it, the greater our hunger and our craving. And this is the life of love in its highest working, above reason and above understanding ; for reason can here neither give nor take away from love, for our love is touched by the Divine love.

BURNING AIR AND GLOWING FIRE

In describing the most intimate union with God, ' union without intermediary,' he is careful to avoid any suggestion of pantheism, as the following passage shows :

If a man then wishes to penetrate further, with his active love, into that fruitive love : then, all the powers of his soul must give way, and they must suffer and patiently endure that piercing Truth and Goodness which is God's self. For, as the air is penetrated by the brightness and heat of the sun and iron is penetrated by fire ; so that it works through fire the works of fire, since it burns and shines like the fire ; and so likewise it can be said of the air—for, if the air

had understanding, it could say : ' I enlighten and brighten the whole world '—yet each of these keeps its own nature. For the fire does not become iron, and the iron does not become fire, though their union is without means ; for the iron is within the fire and the fire within the iron ; and so also the air is in the sunshine and the sunshine in the air. So likewise is God in the being of the soul ; and whenever the soul's highest powers are turned inward with active love, they are united with God without means, in a simple knowledge of all truth, and in an essential feeling and tasting of all good.

THE EBB AND FLOW OF GOD

Now understand this : this man shall go out and observe God in His glory with all saints. And he shall behold the rich and generous outflowing of God, with glory and with Himself, and with inconceivable delights towards all the saints, according to the longing of all spirits ; and how these flow back, with themselves, and with all that they have received and can achieve, towards that same rich Oneness from which all bliss comes forth.

This flowing forth of God always demands a flowing back ; for God is a Sea that ebbs and flows, pouring without ceasing into all His beloved according to the need and the merits of each, and ebbing back again with all those who have been thus endowed, both in heaven and on earth, with all that they have and all that they can. And of some He demands more than they are able to bring, for He shows Himself so rich and so generous and so boundlessly good ; and in showing Himself thus He demands love and adoration according to His worth. For God wishes to be loved by us according to the measure of His nobility, and in this all spirits fail ; and therefore their love becomes

wayless and without manner, for they know not how
they may fulfil it, not how they may come to it. For
the love of all spirits is measured : and for this reason
their love perpetually begins anew, so that God may
be loved according to His demand and to the spirits'
own desires. And this is why all blessed spirits per-
petually gather themselves together and form a burning
flame of love, that they may fulfil this work, and that
God may be loved according to His nobility. Reason
shows clearly that to creatures this is impossible ;
but love always wills the fulfilment of love, or else
will be consumed, burned up, annihilated in its own
failure. Yet God is never loved according to His
worth by any creatures. And to the enlightened
reason this is a great delight and satisfaction : that its
God and its Beloved is so high and so rich that He
transcends all created powers, and can be loved
according to His merits by none save Himself.

BLESSED HENRY SUSO

c. 1295–1366

HENRY SUSO belonged to Oberlingen on the lake of Constance, and became a Dominican at an early age. When he was eighteen he dedicated himself to the service of the Eternal Wisdom, and sealed himself thereto by cutting in his flesh the sacred monogram I H S. From 1324 to 1327 he did a post-graduate course of theology at Cologne, where he was a disciple of Eckhart, and wrote his first book, *Büchlein der Wahrheit*. His association with Eckhart brought him under suspicion for a time, and he was removed from his lectorate at Cologne.

In his earlier years Blessed Henry collected a veritable arsenal of 'instruments of penitence,' which he used on himself with excessive zeal. He grew wiser with age, and when he was about forty threw them all into the Rhine, exchanging them for the passive mortifications of the 'dark night of the spirit' and other spiritual and moral trials. He was, for example, accused by one of his penitents of being the father of her child. He gave up his whole being to Christ, keeping his soul peaceful and sweet amid all adversities. 'God is good and He is good to me,' he would reply when asked why he was so cheerful. He died at Ulm in 1366 and was declared blessed in 1831.

Suso collected his spiritual autobiography, his 'Book of Wisdom' and 'Book of Truth,' and a number of letters into one volume called *The Exemplar*. In his writing he is a good literary artist and shows himself a man of sensibility and loving nature. Few books, except the *Imitation*, exceeded his *Eternal Wisdom* in popularity up to the fifteenth century. It sets out how joy flows from suffering, and draws the reader to the realm of contemplation that Suso himself dwelt in so peacefully.

TRANSLATIONS : *Œuvres mystiques du bienheureux Henri*

9

Suso (2 vols., Paris, 1899). *A Little Book of Eternal Wisdom.*
Translated by Father C. H. McKenna, O.P. (Burns Oates &
Washbourne, 1910).

GOD'S LOVEABLENESS

The Servant.—Lord, let me reflect on that Divine
passage, where Thou speakest of Thyself in the book
of Wisdom : ' Come over to Me, all ye that desire
Me, and be filled with My fruits. I am the Mother
of fair love ; My spirit is sweet above honey and the
honeycomb. Wine and music rejoice the heart, but
the love of wisdom is above them both.'[1]
 Ah, Lord ! Thou canst show Thyself so lovely
and so tender, that all hearts must needs languish
for Thee and endure, for Thy sake, all the misery
of tender desire ; Thy words of love flow so sweetly
out of Thy sweet mouth, and so powerfully affect
many hearts in their days of youthful bloom, that
perishable love is wholly extinguished in them. O my
dear Lord, this it is for which my soul sighs, this it is
which makes my spirit sad, this it is about which I
would gladly hear Thee speak. Now, then, my only
elected Comforter, speak one little word to my soul,
to Thy poor handmaid ; for, lo ! I am fallen softly
asleep beneath Thy shadow, and my heart watcheth.
 Eternal Wisdom.—Listen, then, My son, and see,
incline to Me thy ears, enter wholly into thy interior,
and forget thyself and all things. I am in Myself the
incomprehensible good, which always was and always
is, which never was and never will be uttered. I may
indeed give Myself to men's hearts to be felt by them,
but no tongue can truly express Me in words. And
yet, when I, the Supernatural, immutable good,
present Myself to every creature according to its
capacity to be susceptible of Me, I bind the sun's

[1] Ecclesiasticus xxiv, 24, 26, 27 ; xl, 20.

splendour, as it were, in a cloth, and give thee spiritual perceptions of Me and of My sweet love in bodily words thus : I set Myself tenderly before the eyes of thy heart ; now adorn and clothe thou Me in spiritual perceptions and represent Me as delicate and as comely as thy very heart could wish, and bestow on Me all those things that can move the heart to especial love and entire delight of soul. Lo ! all and everything that thou and all men can possibly imagine of form, of elegance, and grace, is in Me far more ravishing than anyone can express, and in words like these do I choose to make Myself known. Now, listen further : I am of high birth, of noble race ; I am the Eternal Word of the Fatherly Heart, in which, according to the love-abounding abyss of My natural Sonship in His sole paternity, I possess a gratefulness before His tender eyes in the sweet and bright-flaming love of the Holy Ghost. I am the throne of delight, I am the crown of salvation, My eyes are so clear, My mouth so tender, My cheeks so radiant and blooming, and all My figure so fair and ravishing, yea, and so delicately formed, that if a man were to lie in a glowing furnace till the day of judgement, only to have one single glance at My beauty, he would not deserve it. See, I am so deliciously adorned in garments of light, I am so exquisitely set off with all the blooming colours of living flowers, that all May-blossoms, all the beautiful shrubs of all dewy fields, all the tender buds of the sunny meads, are but as rough thistles compared to My adornment.

> In the Godhead I play the game of bliss,
> Such joy the angels find in this,
> That unto them a thousand years
> But as one little hour appears.

All the heavenly host follow Me entranced by

new wonders, and behold Me ; their eyes are fixed
on Mine ; their hearts are inclined to Me, their minds
bent on Me without intermission. Happy is he who,
in joyous security, shall take Me by My beautiful hand,
and join in My sweet diversions, and dance for ever
the dance of joy amid the ravishing delights of the
kingdom of heaven ! One little word there spoken by
My sweet mouth will far surpass the singing of all
angels, the music of all harps, the harmony of all
sweet strings. My faithfulness is so made to be loved,
so lovely am I to be embraced, and so tender for pure
languishing souls to kiss, that all hearts ought to break
for My possession. I am condescending and full of
sympathy and always present to the pure soul. I
abide with her in secret, at table, in bed, in the streets,
in the fields. Turn Myself whichever way I will, in
Me there is nothing that can displease, in Me is
everything that can delight the utmost wishes of thy
heart and desires of the soul. Lo ! I am a good so
pure, that he who in his day only gets one drop
of Me regards all the pleasures and delights of this
world as nothing but bitterness ; all its possessions
and honours as worthless, and only fit to be cast
away ; My beloved ones are encompassed by My
love, and are absorbed into the One Thing alone
without imaged love and without spoken words, and
are taken and infused into that good out of which
they flowed. My love can also relieve regenerate
hearts from the heavy load of sin, and can give a free,
pure, and gentle heart, and create a clean conscience.
Tell Me, what is there in all this world able to outweigh
this one thing ? For he who gives his heart wholly
to Me lives joyfully, dies securely, and obtains the
kingdom of heaven here as well as hereafter.

Now, observe, I have assuredly given thee many
words, and yet My beauty has been as little touched
by them as the firmament by thy little finger, because
no eye has ever seen My beauty, nor ear heard it,

neither has it ever entered any heart. Still let what I have said to thee be as a device to show thee the difference between My sweet love and false, perishable love.

The Servant.—Ah ! Thou tender, delicious, wild flower, Thou delight of the heart in the embracing arms of the pure loving soul, how familiar is all this to him who has even once really felt Thee ; but how strange is it to that man who knows Thee not, whose heart and mind are still of the body ! O, Thou most heart-felt incomprehensible good, this is a precious hour, this is a sweet moment, in which I must open to Thee a secret wound which my heart still bears from Thy sweet love. Lord, plurality in love is like water in the fire. Lord, Thou knowest that real fervent love cannot bear duality. Alas ! Thou only Lord of my heart and soul, my heart desires that Thou shouldst have a particular love for me, and that I should be particularly pleasing to Thy divine eyes. O Lord, Thou hast so many hearts that ardently love Thee, and are of much account with Thee. Alas ! my sweet and tender Lord, how stands it with me in this matter ?

Eternal Wisdom.—My love is of that sort which is not diminished in unity, nor confounded in multiplicity. I am as entirely concerned and occupied with thee alone, with the thought how I may at all times love thee alone, and fulfil everything that appertains to thee, as though I were wholly disengaged from all other things.

The Servant.—O rare ! O wonderful ! whither am I borne, how am I gone astray ! how is my soul utterly dissolved by the sweet friendly words of my beloved ! Oh, turn away Thy bright eyes from me, for they have overcome me.[1] Wherever was there a heart so hard, a soul so lukewarm, so cold as, when it heard Thy sweet living words, so exceedingly fiery

[1] Cant. vi, 5.

as they are, was not fain to melt and kindle in Thy
sweet love! O wonder of wonders! that he who
thus sees Thee with the eyes of his soul, should not feel
his very heart dissolve in love! How right blessed is he
who bears the name of Thy Spouse, and is so! What
sweet consolations and secret tokens of Thy love
must not he eternally receive from Thee! O thou
sweet virgin St. Agnes, thou fair wooer of Eternal
Wisdom! how well couldst thou console thyself
with thy dear Bridegroom, when thou didst say,
'His blood has adorned my cheeks as with roses.'
O gentle Lord, that my soul were but worthy to
be called Thy wooer! And were it indeed possible
that all delights, all joy and love, that this world
can afford, might be found united in one man, how
gladly would I renounce him for the sake of that name!
How blessed is that man, that ever he was born into
the world, who is named Thy friend, and is so! Oh,
if a man had even a thousand lives, he ought to stake
them at once for the sake of acquiring Thy love. Oh,
all ye friends of God, all ye heavenly host, and thou
dear virgin St. Agnes, help me to pray to Him;
for never did I rightly know what His love was.
Alas! thou heart of mine, lay aside, put away all
sloth, and see if, before thy death, thou mayest
advance so far as to feel His sweet love. O thou
tender beautiful Wisdom! O my elected one!
What a truly right gracious love Thou canst be above
all loves else in the world! How very different is Thy
love and the love of creatures! How false is every-
thing that appears lovely in this world and gives
itself out to be something, as soon as one really begins
to know it. Lord, wherever I might cast my eyes
I always found something to disgust me; for, if it
was a fair image, it was void of grace; if it was fair
and lovely, it had not the true way; or if it had
indeed this, still, I always found something, either
inwardly or outwardly, to which the entire inclination

of my heart was secretly opposed. But Thou art beauty with infinite affability, Thou art grace in shape and form, the word with the way, nobility with virtue, riches with power, interior freedom and exterior brightness, and ONE thing Thou art which I have never found in time, namely, a power and faculty of perfectly satiating every wish and every ardent desire of a truly loving heart. The more one knows Thee, the more one loves Thee ; the more acquainted one is with Thee, the more friendly one finds Thee. Ah me ! what an un-fathomable, entirely pure, good Thou art ! See how deceived all those hearts are that fix their affections on anything else ! Ah ! ye false lovers, flee far from me, never come near me more. I have chosen for my heart that one only love in which my heart, my soul, my desire, and all my powers can alone be satiated with a love that never dissolves away. O Lord, could I but trace Thee on my heart ! could I but melt Thee with characters of gold into the innermost core of my heart and soul, so that Thou mightest never be eradicated out of me ! Oh, misery and desolation ! that ever I should have troubled my heart with such things ! What have I gained with all my lovers, but time lost, forfeited words, an empty hand, few good works, and a conscience burdened with infirmity ? Slay me, rather, in Thy love, O Lord, for from Thy feet I will never more be separated.

Eternal Wisdom.—I go forth to meet those who seek Me, and I receive with affectionate joy such as desire My love. All that thou canst ever experience of My sweet love in time, is but as a little drop to the ocean of My love in eternity.

THE WORTH OF TEMPORAL TRIALS

The Servant.—Tell me now, tender Lord, what this suffering is which Thou thinkest so very profitable and good ?

Eternal Wisdom.—What I mean is every kind of suffering, whether willingly accepted or unwillingly incurred—as when a man makes a virtue of necessity in not wishing to be exempt from suffering without My will, and ordering it, in humble patience, to My eternal praise ; and the more willingly he does this, the more precious and agreeable it is to Me. Touching such kinds of suffering, hear further, and write it down in the bottom of thy heart, and keep it as a sign to set before the spiritual eyes of thy soul. My dwelling is in the pure soul as in a paradise of delights, for which reason I cannot endure that she should lovingly and longingly attach herself to anything. But, from her very nature, she is inclined to pernicious lusts, and therefore I encompass her path with thorns. I garnish all her outlets with adversity, whether she like it or not, so that she may not escape from Me ; her ways I strew with tribulation, so that she may not set the foot of her heart's desire anywhere except in the loftiness of My divine nature. And if all hearts were but one heart, they would not be able to bear even that least reward which I certainly will give for the suffering endured by anyone for love of Me. Such is My eternal order in all nature, from which I do not swerve ; what is precious and good must be earned with bitterness ; he who recoils at this, let him recoil ; many are indeed called, but few are chosen.

The Servant.—It may well be, Lord, that suffering is an infinite good, provided it be not without measure, and not too dreadful and overwhelming. Lord, Thou alone knowest all hidden things, and didst create all

things in weight, in number and measure ; Thou knowest also that my sufferings are measureless, that they are wholly beyond my strength. Lord, is there anyone in all this world who has constantly more painful sufferings than I ? They are to me invincible —how am I to endure them ? Lord, if Thou wouldst send me ordinary sufferings, I could bear them, but I do not see how I can ever endure such extraordinary sufferings as these—sufferings which in so hidden a manner oppress my heart and soul, which only Thou canst perfectly understand.

Eternal Wisdom.—Every sick man imagines that his own sickness is the worst, and every man in distress, his own distress the greatest. Had I sent thee other sufferings it would have been the same. Conform thyself freely to My will under every pain which I ordain thee to suffer, without excepting this or the other suffering. Dost thou not know that I only desire what is best for thee, even with as kindly a feeling as thou thyself? Hence it is that I am the Eternal Wisdom, and that I know better than thou what is for thy good. Hence it is that thou mayst have felt that the sufferings which I send are much more exquisite, and penetrate deeper, and operate better, for him who does them justice, than all self-chosen sufferings. Why then dost thou so complain to Me ? Address Me rather as follows : O my most faithful Father, do to me at all times what Thou wilt !

The Servant.—O Lord, it is so easy to talk, but the reality is so difficult to endure, for it is so very painful.

Eternal Wisdom.—If suffering gave no pain, it could not be called suffering. There is nothing more painful than suffering, and nothing more joyful than to have suffered. Suffering is a short pain and a long joy. Suffering gives to the sufferer pain here and joy here-after. Suffering kills suffering. Suffering is ordained that the sufferer may not suffer eternally. Hadst thou

so much spiritual sweetness and Divine consolation and heavenly delight as, at all times, to overflow with the Divine dew, it would not be for thee so very meritorious of itself, since, for all this together, I should not have to thank thee so much ; it could not exculpate thee so much as an affectionate suffering or patience in adversity, in which thou sufferest for My sake. Sooner will ten be perverted and ruined in the midst of a great delight and joyous sweetness than one in the midst of constant suffering and adversity. If thou hadst as much science as all the astronomers, if thou couldst discourse as ably of God as all the tongues of men and angels, and didst possess the treasures of knowledge of all the masters, not all this could avail to advance thee in a good life so much as if thou didst give thyself up, and didst abandon thyself in all thy sufferings to God ; for the former is common to the good and the bad, but the latter is proper to My elect alone. If anyone were able rightly to weigh time and eternity, he ought rather to desire to lie in a fiery furnace for a hundred years than to be deprived in eternity of the smallest reward for the smallest suffering ; for this has an end, but the other is without end.

The Servant.—Ah, sweet and dear Lord, how like a sweet harp are these words to a suffering mortal ! Lord, Lord, wouldst Thou but cheer me thus and come to visit me in my sufferings, I should be glad to suffer ; it would then be better for me to suffer than not to suffer.

Eternal Wisdom.—Now, then, hearken to the sweet music of the distended strings of that Divine harp— a God-suffering man—how richly it sounds, how sweetly it vibrates. Before the world, suffering is a reproach, but before Me it is an infinite honour. Suffering is an extinguisher of My wrath, and an obtainer of My favour. Suffering makes a man in My sight worthy of love, for the sufferer is like Me.

Suffering is a hidden treasure which no one can make good ; and though a man might kneel before Me a hundred years to beg a friendly suffering, he nevertheless would not earn it. Suffering changes an earthly man into a heavenly man. Suffering brings with it the estrangement of the world, but confers, instead, My intimate familiarity. It lessens delight and increases grace. He to whom I am to show Myself a friend, must be wholly disclaimed and abandoned by the world. Suffering is the surest way, the nearest way, and the shortest way. He who rightly knows how profitable suffering is, ought to receive it as a gift worthy of God. Oh, how many a man there is who once was a child of eternal death, and plunged in the profoundest sleep, whom suffering has awakened up and encouraged to a good life. How many a wild beast, how many an untamed bird, there is in human form, whom constant suffering has shut up, as it were, in a cage, who, if anyone were to leave him time and place free, would do his best to escape from his salvation. Suffering is a safeguard against grievous falls ; it makes a man know himself, rely on himself, and have faith in his neighbour. Suffering keeps the soul humble and teaches patience. It is the guardian of purity, and confers the crown of eternal salvation. There is probably no man living but who derives good from suffering, whether he be in a state of sin, or on the eve of conversion, or in the fruition of grace, or on the summit of perfection ; for it purges the soul as fire purges iron and purifies gold ; it adorns the wrought jewel. Suffering takes away sin, lessens the fire of purgatory, expels temptation, consumes imperfections, and renovates the spirit. It imparts true confidence, a clear conscience, and constant loftiness of mind. Know that it is a healthy beverage, and a wholesome herb above all the herbs of paradise. It chastises the body which, at any rate, must rot away, but it nourishes

the noble soul which shall endure for ever. Behold, the noble soul blooms by suffering even as the beautiful rose by the fresh dews of May! Suffering makes a wise mind and an experienced man. A man who has not suffered, what does he know? Suffering is affection's rod, a paternal blow given to My elect. Suffering draws and forces men to God, whether they like it or not. He who is always cheerful in suffering, has for his servants joy and sorrow, friend and foe. How often hast thou not thrust an iron bit between the gnashing teeth of thy enemies, and rendered them, with thy joyous praise, and thy meekness in suffering, powerless? Sooner would I create suffering out of nothing than leave My friends unprovided with it; for in suffering, every virtue is preserved, man adorned, his neighbour reformed, and God praised. Patience in suffering is a living sacrifice, it is a sweet smell of balsam before My Divine face, it is an appealing wonder before the entire host of heaven. Never was a skilful knight in a tournament so gazed at as a man who suffers well is gazed at by all the heavenly court. All the saints are on the side of the suffering man; for, indeed, they have all partaken of it before him, and they call out to him with one voice that it contains no poison, but is a wholesome beverage. Patience in suffering is superior to raising the dead, or the performing of other miracles. It is a narrow way which leads direct to the gates of heaven. Suffering makes us companions of the martyrs, it carries honour with it, and leads to victory against every foe. Suffering clothes the soul in garments of rose colour, and in the brightness of purple; in suffering she wears the garland of red roses, and carries the sceptre of green palms. Suffering is for her as a shining ruby in a young maiden's necklace. Adorned with it, she sings with a sweet voice and a free heart a new song which not all the angelic choirs could ever sing, because they never knew suffering. And, to be short, those

who suffer are called the poor before the world, but before Me they are called the blessed, for they are My elect.

The Servant.—Oh, how plainly does it appear that Thou art the Eternal Wisdom, since Thou canst bring the truth home with such cogency that no one doubts it any longer. No wonder that he, to whom Thou dost make suffering appear so lovely, can bear sufferings. Lord, in consequence of Thy words, all sufferings in future must be easier, and full of joy for me. Lord, my true Father, behold, I kneel before Thee this day, and praise Thee fervently for my present sufferings, and also for the measureless sufferings of the past, which I deemed so very great, because they appeared so hostile to me.

Eternal Wisdom.—But what is thy opinion now?

The Servant.—Lord, my opinion in very truth is this : that when I look at Thee, Thou delight of my eyes, with looks of love, the great and violent sufferings with which, in so paternal a manner, Thou hast disciplined me, and at the sight of which Thy pious friends were filled with such terror on my account, have been like a sweet fall of dew in May.

RICHARD ROLLE

c. 1300–1349

RICHARD ROLLE, the Hermit of Hampole, was born probably at Thornton-le-Dale in Yorkshire ; his parents were poor, but with the help of the archdeacon of Durham, Thomas de Neville, he was able to go to Oxford. It is very probable that he went on to Paris and took his doctorate there, and he may have been a priest : but this is not certain.

When he came back to England he determined to attain his long-cherished wish to be a hermit, and this he did in spite of strong opposition from his father. He reached the heights of contemplation and Divine love, and this same love prompted him to write down his experiences, especially for the benefit of those whom he directed, such as the anchoress Margaret Kirkby of Anderby, and the Cistercia nuns at Hampole. He writes very beautifully, particularly on his favourite subject of God's love. His chief works, e.g. *The Fire of Love* and *The Amending of Life*, were written in Latin, but he also wrote in that mixture of Old English, Norman-French, and Latin, which is the basis of modern English. Rolle has accordingly been called the father of English prose. He was the most prolific of English spiritual writers of the Middle Ages,[1] and many people consider him the greatest. His works were very popular both at home and abroad in mediæval times, and his reputation for holiness brought him visitors from all parts.

WORKS : *Eight Prose Treatises.* Edited by G. G. Perry. (E.E.T.S., 1921.)

The Fire of Love and the *Mending of Life.* Misyn's translation, edited by R. Harvey. (E.E.T.S., 1896.) Modern translation by F. M. Comper. (London, 1914.)

[1] For an account of them see the excellent book of Dom David Knowles, *The English Mystics* (Burns Oates & Washbourne, 1927).

The Form of Perfect Living. Modernized by Geraldine
E. Hodgson. (London, 1910.)
 The Minor Works. Edited by the same. (London, 1923.)
 The Amending of Life. Edited by A. P. (Burns Oates
& Washbourne, 1927.)
 Selected Works. Transcribed by G. C. Heseltine.
(London, 1930.)

THE THREE DEGREES OF LOVE

MYSTICAL writers have divided love in many ways.
Some refer to three degrees, others to four, five, seven,
twelve. The division into three degrees by Richard
Rolle is a very fine and very original one. It seems
to have been specially dear to the author, for he comes
back to it in several of his treatises.

 Three degrees of love I shall tell thee, for I would
that thou might win to the highest. The first degree
is called *Insuperable*, the second *Inseparable*, the third
Singular.

 Thy love is *Insuperable* when nothing that is contrary
to God's love overcomes it, but it is stalwart against
all temptations and stable whether thou be in ease
or anguish, in health or sickness. So that thou thinkest
that thou wouldst not, for all the world and to have it
for ever, at any time make God wrath. And thou
wouldst rather, if it should be so, suffer all the pain
that might come and all the woe, before thou wouldst
do the thing that would displease Him. In this manner
shall thy love be *Insuperable*, that nothing may bring
it down, but it may be ever springing on high. Blessed
is he or she that is in this degree : but they are yet
more blessed that might keep this degree and win to
the other, that is *Inseparable*.

 Thy love is *Inseparable* when all thy heart and thy
thought and thy might are so wholly, so entirely
and so perfectly fastened, set and established in Jesus
Christ, that thy thought goes never from Him,

except sleeping : and as soon as thou dost waken, thy heart is on Him saying *Ave Maria* or *Gloria tibi Domine* or *Pater Noster* or *Miserere mei Deus* if thou hast been tempted in thy sleep ; or thinking on His love and His praise as thou didst waking. When thou mayest at no time forget Him, whatsoever thou dost or sayest, then is thy love *Inseparable*. Very great grace have they that are in this degree of love. And I think that thou who hast nothing else to do but to love God, mayest come thereto if any may.

The third degree is highest and most wondrous to win. That is called *Singular*, for it has no peer. Singular love is when all comfort and solace are closed out of thy heart, but that of Jesus Christ alone. It seeks no other joy. For the sweetness of him that is in this degree is so comforting and lasting in His love, so burning and gladdening, that he or she who is in this degree may feel the fire of love burning in their souls as well as thou mayest feel thy finger burn if thou dost put it in the fire. But that fire, though it be hot, is so delectable and wonderful that I cannot describe it.

Then thy soul is Jesus-loving, Jesus-thinking, Jesus-desiring, only breathing in the desire of Him, singing to Him, burning for Him, resting in Him. Then the song of praise and love is come. Then thy thought turns to love and melody. Then it behoves thee to *sing* psalms that before thou didst *say*. Then must thou take long over a few psalms. Then wilt thou think death sweeter than honey, for then thou art full certain to see Him whom thou lovest. Then mayest thou boldly say : ' I languish for love.' Then mayest thou say : ' I sleep and my heart watches.'

In the first degree men may say : ' I languish for love ' and ' I long for love,' and in the other degree also. For languishing is when men faint because of sickness, and they that are in these two degrees fall from all the desires of this world and from the lust

and pleasure of sinful life, setting their intent and their hearts to the love of God. Therefore they may say : ' I languish for love,' and much more they that are in the second degree than in the first. But the soul that is in the third degree is like a burning fire, and as the nightingale that loves song and melody and faints for great love ; so that the soul is so much comforted in the praise and loving of God, and till death comes is singing spiritually to Jesus, and in Jesus, and of Jesus, not crying bodily with the mouth, of which manner of singing I do not speak, for both good and bad have that song, and this manner of song nobody has unless he be in the third degree of love. To which degree it is impossible to come but in great plenitude of love.

Therefore if thou wilt know what kind of joy that song has, I tell thee that no man knows but he or she that feels it, that has it, and that praises God therewith. One thing I tell thee : it is of heaven and God gives it to whom He will, but not without great grace coming before. Who has it thinks all the song and all the minstrelsy of earth but sorrow and woe beside it. In sovereign rest shall they be who may gain it. Wanderers and babblers and those who keep visitors early and late, night and day, or any that are entangled with sin wilfully and wittingly, or that have delight in any earthly thing, they are as far therefrom as heaven is from earth.

In the first degree there are many, in the other degree there are very few, but in the third degree there are scarcely any. For always the greater the perfection is, the fewer followers it has. Men in the first degree may be likened to the stars, in the other to the moon, in the third to the sun. (' The Form of Living.' Chapter VIII.)[1]

[1] *Selected Works of Richard Rolle*, transcribed by G. C. Heseltine. (Longmans, Green & Co., London, 1930), pp. 35–38.

A SONG OF LOVE

My song is a sighing, my life is spent in longing for the sight of my King, so fair in His brightness.

So fair in Thy beauty! Lead me to Thy light, and feed me on Thy love! Make me to grow swiftly in love and be Thou Thyself my prize.

When wilt Thou come, Jesus my joy, to save me from care and give Thyself to me, that I may see Thee evermore?

Could I but come to Thee, all my desires were fulfilled. I seek nothing but Thee alone, who art all my desire.

Jesus my Saviour! My comforter! Flower of all beauty! My help and my succour! When may I see Thee in Thy majesty?

When wilt Thou call me? I languish for Thy presence, to see Thee above all things. Let not Thy love for me fail! In my heart I see the canopy that shall cover us both.

Now I grow pale and wan for love of my beloved Jesus both God and man. Thy love did teach me when I ran to Thee, wherefore now I know how to love Thee.

I sit and sing of the love-longing that is bred in my breast. Jesus! Jesus! Jesus! Why am I not led to Thee?

Full well I know Thou seest my state. My thought is fixed upon love. When I shall see Thee and dwell with Thee, then shall I be filled and fed.

Jesus, Thy love is constant and Thou knowest best how to love me. When shall my heart break forth to come to Thee, my rest?

Jesus, Jesus, Jesus! I mourn for Thee! When may I turn hence to Thee, my life and my living?

Jesus, my dear and my darling! My delight is to sing of Thee. Jesus my mirth and my melody! When wilt Thou come, my king?

Jesus, my salvation and my sweetness, my hope and my comfort ! Jesus, I desire to die whenever it shall please Thee. The longing that my Love has sent to me overwhelms me.

All woe is gone from me, since my breast has been inflamed with the love of Christ so sweet, whom I will never leave, but do promise to love always.

For love can cure my evil and bring me to His bliss, and give me Him for whom I sigh, Jesus, my love, my sweeting.

A longing has come upon me that binds me day and night until I shall see His face so fair and bright.

Jesus, my hope, my salvation, my only joy ! Let not Thy love cool, let me feel Thy love and dwell with Thee in safety.

Jesus, with Thee alone I am great. I would rather die than possess all this world and have power over it.

When wilt Thou pity me, Jesus, that I may be with Thee, to love Thee and look upon Thee ?

Do Thou ordain for me my settle and sit me thereon, for then we can never part.

And I shall sing of Thy love, in the light of the brightness of Heaven for ever and ever. Amen.

(Transcription by G. C. Heseltine. *Selected Works*, pp. 98–100.)

A PRAYER TO LOVE

O SWEET and delectable light, that is my infinite maker, enlighten the face and the vision of my inward eye with uncreated charity, and kindle my mind with Thy savour, that, thoroughly cleansed from uncleanness and made marvellous with Thy gifts, it may swiftly fly to the high mirth of love ; that I may sit and rest in Thee, Jesus, rejoicing and going as it were, ravished with heavenly sweetness ; and that, established in the beholding of heavenly things, I shall never be glad but in Divine things.

O Love everlasting, inflame my soul to love God, that nothing may burn in me but His embraces. O good Jesus, who shall grant me to feel Thee, who now neither may be felt nor seen ? Shed Thyself into the entrails of my soul ! Come into my heart and fill it with Thy most excellent sweetness. Inebriate my mind with the hot wine of Thy sweet love, that, forgetting all evils and all scornful visions and imaginations, and having Thee alone, I may be glad and rejoice in Jesus my God. Henceforward, sweetest Lord, go not from me, but abide with me in Thy sweetness, for Thy presence alone is solace to me and Thine absence alone leaves me sad.

O holy Ghost, that givest grace where Thou wilt, come into me and ravish me to Thyself. The nature that Thou didst make, change with honeysweet gifts, that my soul, filled with Thy delightful joy, may despise and cast away all the things of this world, that it may receive ghostly gifts, given by Thee, and going with joyful songs into infinite light may be all melted in holy love. Burn with Thy fire my reins and my heart that on Thine altar shall burn for ever.

Come, I beseech Thee, O sweet and true Joy ! Come, sweet and most desired ! Come, my love, who art all my comfort ! Come with mellifluous heat into a soul longing for Thee and yearning with sweetest ardour towards Thee. Kindle with Thy heat the whole of my heart, enlightening with Thy light my inmost parts ; feed me with the honeysweet song of love, as much as the powers of my body and soul can endure. (' The Amending of Life.' Chapter XI. *Selected Works*, pp. 136–137.)

ON EXCESS OF PENANCE

ONE of the characteristics of Richard Rolle is his great ' reasonableness.' Though himself much addicted

to great austerities he repeatedly deprecates the practice of excessive penance.

Some are beguiled with *overmuch abstinence from meat and drink and sleep*. That is a temptation of the devil, to make them fall in the midst of their work, so that they bring it not to an end as they should have done, if they had known reason and kept discretion. And so they lose their merit for their forwardness. This trap our enemy lays to take us with, when we begin to hate wickedness and turn ourselves to God. Then many begin a thing that they may never bring to an end. Then they think they may do whatsoever their heart is set upon. But often they fall ere they reach half-way, and that thing which they thought was for them is hindering them. For we have a long way to heaven, and as many good deeds as we do, as many prayers as we make, and as many good thoughts as we think in truth and hope and charity, so many paces do we go heavenward. Then if we make ourselves so feeble that we may neither work nor pray as we should, nor think, are we not greatly to blame that fail when we have most need to be stalwart? And well I know that it is not God's will that we do so. For the prophet says : ' Lord, I shall keep my strength to Thee.' So that he might sustain God's service to his death-day, and not in a little and in a short time waste it and then lie wailing and groaning by the wall. And the peril is much more than men think. For St. Jerome says that he makes an offering of robbery who excessively torments his body with too little meat or sleep. And St. Bernard says : ' Fasting and watching hinder not ghostly good, but help, if they be done *with discretion*—without that they are vices.' Therefore it is not good to punish ourselves so much and afterwards have no thanks for our deed. (' The Form of Living,' Chapter I, *Selected Works*, p. 17.)

JOHN TAULER

c. 1304–1361

In spite of his great fame we have little certain knowledge of John Tauler. He was born probably at Strasbourg and of a well-to-do family, and he became a Dominican in that city, where he studied philosophy and theology for eight years. There he came under the influence of the current ' Dionysian ' mysticism and of St. Thomas Aquinas, with whom he disagreed on more than one point.

From Strasbourg he seems to have gone to Cologne, where he probably met Blessed Henry Suso and the famous Master Eckhart, whose lectures he may have attended. He was certainly a great admirer of Eckhart, and was the inheritor of his teaching, which he defended from attack, trying to explain in an orthodox sense the propositions condemned by Pope John XXII. Many passages in Tauler's sermons are no more than a faithful echo of Eckhart's thought, but he had the discretion and prudence which his master lacked and carefully modified his over-daring statements ; moreover, he enjoyed mystical experience which would seem to have been denied to Eckhart.

It is believed that Tauler stayed for a time in Paris where he met the masters in theology to whom he so often alludes in his sermons, but in 1336 he was back at Strasbourg. He was then about thirty-two, and already renowned as a zealous apostle and fine preacher. Eighty-three of his authentic sermons are extant, most of them addressed to contemplative Dominican nuns, whose convents were then numerous in the Rhenish provinces. That is probably the reason why he did not consider it necessary to insist over-much on ascetical practices and gave his discourses a very strong mystical appeal. The great sermons in which Tauler explained to the nuns

the deep problems which preoccupied him, and of which he was professor to his Dominican brethren, are of a highly speculative character ; they deal with the nature of God, His attributes, the nature and faculties of the soul, the different ways of attaining to knowledge of God, etc. Much has been talked about the relations of Tauler and Ruysbroeck, but little is known about them except that they probably knew one another at Groenendael.

WORKS : The eighty-three sermons are the only certain works of Tauler. These have recently been translated into French by Pères Hugueny and Thery, O.P. (*Editions de la Vie Spirituelle* ; Paris, 1927). The famous book of fourteenth-century mysticism called *Erleuchten* is a compilation from the writings of Eckhart, Ruysbroeck, and Tauler made by St. Peter Canisius (Peter of Nimwegen).[1]

Meditations on the life and Passion of our Lord Jesus Christ. Attributed to John Tauler. (Burns Oates & Washbourne.)

THE HUNTING OF THE SOUL

IN his sermon for the Monday after Passion Sunday, Tauler speaks of the Passion and of the soul pursued by the hounds of temptation.

Summary : How we ought to share the passion of our Lord. The thirst for God. It increases like the thirst of a hunted hind. First the big hounds, then the little ones. A moment's rest and refreshment. The hind at the water-spring. *Si quis sitit, veniat et bibat* (John vii, 37).

1. On the last day of the Feast of Tabernacles our Lord cried aloud, saying, 'If any man thirst, let him come to Me and drink ! '

We are about to commemorate the worshipful passion of our Saviour, and no one should part from the thought of it without his heart being moved to compassion and gratitude. Since God, our Eternal Father and our Lord, suffered such shames and pains,

[1] The first book published by a Jesuit.

so those who seek to be His lovers should gladly
suffer with Him : whether good or ill befall them it is
meet that they be joyful in the honour and happiness
that enable them to become like to their friend and to
follow Him in the way He has trodden.

2. He says to us, 'If any man thirst . . .' What
is this thirst ? Quite simply, it is this : When the
Holy Spirit comes into the soul and kindles there the
fire of love, the flames throw out blazing sparks
which cause a thirst, a delightsome longing for God ;
sometimes a man does not know what it is that has
happened to account for his distress and his distaste
for all created things. This longing shows itself in
three ways, according to the three different classes
of people who experience it : beginners, those who
have made some progress, and those who are called
' perfect,' in so far as perfection is possible in this
world.

3. The holy king David says in his psalter, ' As the
hart panteth after the fountains of water, so my soul
panteth after thee, O God.' The hart run by hounds
through woods and broken country suffers a thirst
greater than that known to any other animal. So
the beginner in the ways of charity when temptations
pursue him. From the moment that he turns from
the world, seven strong hounds are after him : they
are the seven deadly sins, who follow him with tempta-
tions far stronger than he has known before ; formerly
they took him by surprise, now he is conscious of them
all the time, according to the word of Solomon :
' Son, when thou comest to the service of God . . .
prepare thy soul for temptation.' The hotter this
chase becomes the greater is the thirst and the more
burning the desire for God. Sometimes it happens
that a hound comes up with its quarry and hangs
on to the hart's belly with its teeth ; when it can't
shake it off, the hart drags the dog to a tree and crushes
its head against it until it looses hold. . . . A man

has to do an exactly similar thing. When he has not the mastery over pursuing temptations he must hasten to the tree of the Cross and Passion of our Lord Jesus Christ, banging temptation's head against it until it is broken ; there man can triumph and be free.

4. But when the hart has shaken off the hounds he is often pestered by terriers snapping around him, and though he keeps them away with horns and hoofs they eventually tire him out. So again with man. Having got the victory over big sins, he does not guard sufficiently against occasions of smaller faults : chance acquaintances, wordly company, fine clothes, innocent recreations, such trifles can take a bite here and a bite there, that is to say, they can dissipate a man's heart and conscience until, like the hart, his religious life gets weakened. His enthusiasm and devotion are lost, every thought of God and Divine things may vanish, and thus the terriers can do him more harm than serious temptations : against them he is on his guard, but for the little things he is not careful. It is the same with all things whose danger we don't realize or about which, while harmless in themselves, we are insufficiently careful : they may be much more harmful than those whose danger we know.

And just as the hunted stag gets hotter and more thirsty so indeed does the Divine heat and thirst increase in man as each temptation thrusts him towards God, where alone he can find truth and peace, justice and pity.

5. When the hart is worn out and failing, the huntsmen sometimes call off the hounds (when they are sure they won't lose their animal) and give it a few minutes' ' breather ' so that it may run the better. Our Lord does in like manner. When He sees that the stress of temptation is being too much for a man, He gives him relief therefrom and touches his lips with a sweet taste of Divine things. Man is so

strengthened thereby that he feels himself rise above all his wretchedness, and everything that is not God seems nothing worth—but it is only refreshment for further pursuit : at the moment when he least expects it the hounds are at his throat more fiercely than ever and he has need of all his fresh courage and strength.

God's tenderness and love for us are the cause of this pursuit, for thus man, the hunted stag, runs towards the God who is his true goal ; thus is he made greatly to long and thirst after Him who is all truth, all peace, and the fullest consolation ; thus is the drink that will satisfy that thirst made yet more desirable and delightful both here in time and later in eternity. Then, man will drink open-throatedly at the source of the sweetest of all water-springs, the heart of the Father ; now, he experiences such consolation that all things earthly seem worthless, and suffering for God's sake is as nothing.

6. When the hart has eluded the hounds and reached water he gives himself up to quenching his thirst at his ease. Man, when with Divine help he has shaken off the rabble of dogs, big and little, and reached God, does the same : he drinks at the sacred fountain till he is filled and intoxicated with God, and in the fullness of his happiness forgets himself completely. Then does it seem to him that he could work miracles, pass through fire and water and massed swords, face death itself ; he fears neither life nor death, pleasure nor pain. In this state of exultation sometimes he weeps, sometimes sings, sometimes laughs.

Then the rationalists come along. They know nothing of the marvellous works which the Holy Spirit can do in His own, for they can recognize nothing beyond the gifts of nature. And they say, ' Good Lord ! How worked up and excited you are ! ' . . . But the lovers of God pass into a wordless peace, where all is happiness and joy ; whatever happens

to them, whatever they do, that joy and peace remain, the flames of love leap within them, and the heat makes their heart boil over with happiness. (Sermon for the Monday before Palm Sunday, t. I, pp. 257–262, in *Sermons de Tauler*, traduction par les RR.PP. Hugueny et Théry. Paris, 1927.)

ABANDONMENT TO THE DIVINE WILL

In his three Epiphany sermons he teaches us to rise above ourselves by renouncing our own will, thus preparing the soul for God's work.

Summary : What God wishes above all. The Divine call : *Surge !* One response : by personal effort. The other response : by docile submission to God's will. The wonderful results of this. Difference between the two states of soul. What the submissive soul must do. *Surge et illuminare, Hierusalem* (Is., lx, 1).

1. God wants only one thing in the whole world, the thing which it needs, but He wants it so strongly that the whole of His care is given to it. That thing is to find the innermost part of the noble spirit of man clean and ready for Him to accomplish the Divine purpose therein. God has all power in Heaven and on earth ; but the power to do the finest of His works, in man, against man's will He has not got.

2. What then must man do so that God's light and doing may shine in his inmost part ? He must raise himself ; *Surge*, says the text : ' Arise ! ' Man has to help in the Divine work by lifting himself above self, above creatures, above all that is not God, and by so doing there is born in us an ardent wish to abstract ourselves from and take away from ourselves all unlikeness to Him. The more a man succeeds in this, the more the desire grows, the higher he gets above self, and often, when the inmost soul is stripped,

and touched, the desire gets into his very flesh and bones.

3. Two different sorts of people answer to this interior touch in two different ways.

The one meets it with his own natural ability and disturbs his soul with rational concepts and high speculation ; he silences the wish by wanting to listen to and understand these big thoughts. Such an one finds in them a great satisfaction and imagines that he is a Jerusalem and that he has found peace in the activity of his own reasoning powers. Or else he seeks satisfaction in self-chosen observances, devotions, meditations, whether of his own invention or imitated from others. He proposes to prepare his soul by these means, finds peace in them, and supposes himself to have become a Jerusalem. But he finds this peace only in those devotional observances and works that he has himself selected and arranged, and in no others.

That this is a false peace may easily be recognized from the fact that those who act thus still display their own personal faults, pride, self-indulgence, bodily solicitude, spitefulness, judging of their fellows. If somebody upsets them they complain at once of injuries done to them on purpose and out of dislike. They seem willingly to consent to many of their own shortcomings. Clearly they have got ready their own souls for their own purposes ; God cannot work in them : and therefore their peace is a delusion. They have not really arisen. They ought not to deceive themselves with the idea that they are a Jerusalem and that they have found true peace all by themselves ; they should strive more seriously to overcome their weaknesses and to follow our Lord Jesus Christ in humility and charity, dying to themselves in all things and so learning to raise themselves up.

4. The other category consists of those noble souls who really ' arise,' and thereby are enlightened. They leave their interior spiritual preparation to God

and put themselves completely in His hands. They put everything from them and keep nothing for themselves, neither in good works nor ' devotions,' in what they do or what they don't do, neither here nor there, in gladness or in sorrow ; they receive all from God in humble fear and at the same time give all back to Him in an entire despoiling and resolute abandonment of self to the Divine will. With that they are always satisfied, in weal and in woe, for that, the good and acceptable will of God, is the one thing they regard and value.

To these people may be applied the words of Jesus to His disciples when they urged Him to go into Judæa for the Feast of Tabernacles : ' Go you up to this festival day, your time is always ready. But I go not up, because My time is not accomplished.' Their time is all the time, to give themselves up to God at every moment ; but His time, to do and to enlighten, is at His own disposition and will, and must be awaited with patient submission.

5. The radical distinction between these people and those mentioned before is that they leave the preparing of their inmost soul to God and do not try to do it themselves. Nor do they escape the criticism of the others (nobody does), but if they be convicted of sin, whether pride or sensuality or worldliness or unjust anger or hate or any other wickedness, they at once return humbly to God and again put themselves at the disposition of His will. They in truth arise, for they put self beneath their feet and become a true Jerusalem, finding peace amid strife, and gladness amid misery. They accept God's will, and therefore the whole world cannot wrest their peace from them : devils and men in league cannot deprive them of it. They savour God and nought else, and are truly enlightened, for He pours out His pure light upon them at every turn, even, nay, particularly, at the times when their darkness seems most thick.

These men are supernatural men, Divine men, and God is in their every action ; indeed, if I may put it so, they, in a sense, *are* no longer, but God is in them. They are the most loveable of men ; they bear up the world, they are its columns and piers. Great is the happiness of him who can keep himself in that state.

6. The people who want to prepare their own souls and not give themselves up to God have their faculties entangled in their faults to such a degree that they cannot free them. They don't even want to, but prefer the pleasure of following their own wills. But the others, who have risen above themselves to God, hasten to Him with their misfortune at the first onslaught and victory of sin, in such a way that there is no longer sin, because they enjoy a godlike freedom.

7. Ought not these people, while God prepares their inmost spirit, to undertake on their side some external works ? Should they not be up and doing ? Not necessarily.[1] The text says *Surge*, and that in itself is a work ; moreover, their own particular work which they must be always at, without a break, as long as they live, without which no man can attain perfection. They must be all the time raising themselves, keeping their hearts towards God, freeing the deeps of their soul, asking themselves humbly and fearfully, ' Where is He who is born ? ' and watching out for what God wants that they may do it. If He wishes them to be passive, passive they will be ; if active, then active ; or if contemplative, then will they rejoice in contemplation. They know interiorly that it is God who has made ready the inner room of their soul, and He wishes to dwell therein to the exclusion of all His creatures.

God works within the first class of men *by inter-*

[1] Tauler does not repudiate exterior works, penances, religious exercises ; but he sees them valuable only to the degree that they are required by the Holy Ghost.

mediary, in the second class *without intermediary*.[1] But what He does in these noble and holy souls in immediate contact with Him no one can explain ; one man cannot tell such things to another ; only he can know who has experienced it, and if it indeed be God who has entered into possession of his soul he can say nothing of it. While external works completely disappear for these men, the interior consciousness of God increases, and when one reaches the highest point of which his grace-aided diligence is capable he continues in a state of entire self-nothingness, according to the words of Christ : ' When you shall have done all these things that are commanded you, say, We are unprofitable servants.' Man is never so perfect that he can leave his humble fear, and at the highest degree of perfection he must needs always say and think, *Fiat voluntas tua :* ' Lord, may Thy will be done ! ' And he has to watch with careful attention to see that there is not the smallest inordinate attachment to no matter what, lest God should find something in his soul to hinder the accomplishment of the Divine purpose without intermediary.

May we be enabled thus to arise, that God may do His work in us, and may the all-loving Lord help us so to do ! Amen. (Third sermon for the Epiphany. *Op. cit.* t. I, pp. 197–204.)

TRUE PRAYER

' BE sober and watch ! Because your adversary, the Devil, as a roaring lion goeth about seeking whom he may devour ' (I Pet., v, 8). Watch, that is to say, be

[1] We are in the presence of God without intermediary when we are conscious of His life in us directly, without the help of any created image. This exalted way of prayer is a special gift of God and it cannot be obtained by effort of our personal meditations, even with the help of the Faith and habitual graces ordinary to the Christian life.

vigilant in prayer. Now what sort of prayer had St.
Peter in mind? Not prayer of words (which some
people, for instance, those who say over numberless
psalms, call prayer exclusively), but that which our
Lord meant when He said that true worshippers
worship in spirit and in truth. The saints and teachers
of the Church tell us that prayer is a lifting-up of the
mind to God. Reading and vocal prayer help in
this lifting-up, and it is good to use them for this
purpose ; just as my clothes are useful to me, but
are not me, so spoken words are a help to true prayer
without being that prayer : its essence is that the heart
and mind go out to God without intermediary. True
prayer is simply that, and nothing else : the lifting-up
of the mind to God in love, interior longing for and
humble submission to Him.

Clergy are bound to the recitation of the Divine
Office, but no prayer is so full of love and worship as
the sacred Our Father which our sovereign master
Christ Himself taught to us, and it conduces to true
essential prayer better than any other. It is a heavenly
prayer, which the blessed sing and meditate upon
without ceasing.

St. Augustine says that there is a mysterious place
deep in the soul that is beyond time and this world,
a part higher than that which gives life and movement
to the body ; true prayer so raises the heart that God
can come into this innermost place, the most dis-
interested, intimate, and noble part of our being, the
seat of our unity. It is His eternal dwelling-place,
and into this grand and mysterious kingdom He
pours the sweet delight of which I have spoken. Then
is man no longer troubled by anything : he is re-
collected, quiet, and really himself, and becomes daily
more detached, spiritualized, and contemplative, for
God is within him, reigning and working in the
depths of his soul. This spiritual state of man cannot
be compared with what has gone before, for he has

now taken on a Divine life ; the spirit is set in God, drowned in that fire of charity which is essentially and of its nature God Himself.

Those so happy as to reach this state turn anew to their duties as Christians and direct their prayers and desires to God to ask Him for all things which He wants them to ask ; they remember their friends, sinners, the souls in Purgatory, they seek in their love to satisfy the needs of every man in Christendom, not by praying individually for Joan or for Mrs. Brown,[1] but in a simplified and essential way. Just as with a single look I can see you all here, sitting in front of me, so can they, in the manner of contemplatives, see the whole world. Then they again turn their eyes inward to the burning depths of Divine love and rest therein, and its flames drop like dew upon all the needy in Christendom, returning again to their Divine source.

Thus do these souls go out and return and yet remain in the delightsome and silent deeps where they live and move and have their being. Wherever and whenever we meet them we find that their life is as it were Divine ; all their sayings and doings are godlike. These noble people serve for the good of the whole of Christendom : in them man is aided and consoled, in them God is glorified ; they live in Him, and He lives in them. We are bound to reverence them, always and everywhere.

May we all, God helping us, reach to these heights ! Amen. (Extract from the sermon in preparation for Whitsuntide. *Op. cit.*, t. II, pp. 22–24.)

[1] The original has ' for dame Matilda or for Kunegondis ' (TR.).

THE AUTHOR OF
'THE CLOUD OF UNKNOWING'

Fourteenth century

THE name even is not known of the author of *The Cloud of Unknowing* and other similar treatises, such as *The Epistle of Privy Counsel*, but he certainly lived during the fourteenth century. He is generally thought to belong to its second half, after Richard Rolle and before Walter Hilton. He is far less celebrated than Rolle, but it is none the less true that he may be regarded as the most delicately acute and original of the English mystical writers. The understanding of him is not always easy, especially for a beginner.

Both the ' Cloud ' and the other treatises are full of the ideas of the pseudo-Dionysius, who is often mentioned. Its basic idea, explaining the title, is that God is so far above our knowledge as to be hidden in a cloud of unknowability. It is only by emptying the mind of all created images and the will of all temporal affections that we can arrive at the supreme earthly knowledge of God, a knowledge that consists in knowing that we know nothing about Him and that He infinitely transcends all our apprehensions of Him, however subtle and exalted they may seem.[1]

WORKS : *The Cloud of Unknowing and Other Treatises.* Edited by Dom Justin McCann (Burns Oates & Washbourne, 1924). An excellent edition, including *The Epistle of Privy Counsel*, the translation of the mystical theology of Dionysius, and a commentary on the ' Cloud,' by Father Augustine Baker, O.S.B.

[1] No writer sets forth the same doctrine so well and so similarly to the Englishman as the disciple of St. John of the Cross, Father de Quiroga, O.C.D. His treatise on contemplation was written in Spanish and has not yet been translated into English or French.

CONTEMPLATION

CONTEMPLATION, according to the author, consists in the union of the soul with God through the aspirations of a loving heart called ' meek stirrings of love,' aspirations made in the cloud of unknowing with a confused, very simple and imageless knowledge of God, who is apprehended as the unknowable. Father Baker, in his commentary of *The Cloud of Unknowing*, identifies that contemplation with his own ' prayer of aspirations ' and the confused knowledge of faith of which he often speaks.

HOW THE WORK OF THIS BOOK (CONTEMPLATION) SHALL BE WROUGHT AND OF THE WORTHINESS OF IT BEFORE ALL OTHER WORKS.

Lift up thine heart unto God with a meek stirring of love ; and mean Himself and none of His goods. And thereto look that thou loathe to think on aught but Himself, so that nought work in thy mind nor in thy will but only Himself. And to do that in thee is to forget all the creatures that ever God made and the works of them so that thy thought or thy desire be not directed or stretched to any of them, neither in general nor in special. But let them be, with a seemly recklessness (heedlessness), and take no heed of them.

This is the work of the soul that most pleases God. All saints and angels have joy of this work and hasten them to help it with all their might. All fiends be mad when thou dost so, and try for to defeat it in all that they can. All men living on earth be wonderfully helped by this work, thou knowest not how. Yea, the souls in purgatory are eased of their pains by virtue of this work. Thou thyself art cleansed and made virtuous by no work so much. And yet it is the lightest work of all, when a soul is

helped with grace in a sensible list (delight) and soonest done. But else it is hard and wonderful for thee to do.

Cease not therefore, but travail therein till thou feel list. For at the first time when thou dost it, thou findest but a darkness, and as it were a *cloud of unknowing*, thou knowest not what, saving that thou feelest in thy will a naked intent unto God. This darkness and this cloud, howsoever thou dost, is betwixt thee and thy God, and hindereth thee, so that thou mayest not see Him clearly by light of understanding in thy reason, nor feel Him in sweetness of love in thine affection. And therefore shape thee to bide in this darkness as long as thou mayest, evermore crying after Him whom thou lovest. For if ever thou shalt see Him or feel Him, as it may be here, it must always be in this cloud and in this darkness. And if thou wilt busily travail as I bid thee, I trust in His mercy that thou shalt come thereto. (*The Cloud of Unknowing*, Chapter 3.)[1]

HOW TO ATTAIN GOD BY A NEGATIVE KNOWLEDGE

THAT RIGHT AS BY THE FAILING OF OUR BODILY WIT WE BEGIN MOST READILY TO COME TO THE KNOWING OF GHOSTLY THINGS SO BY THE FAILING OF OUR GHOSTLY WITS WE BEGIN MOST READILY TO COME TO THE KNOWLEDGE OF GOD, SUCH AS IS POSSIBLE BY GRACE TO BE HAD HERE.

And therefore travail fast in this nought, and in this nowhere, and leave thine outward bodily wits

[1] *The Cloud of Unknowing and Other Treatises* with a commentary on the 'Cloud' by Fr. Augustine Baker, O.S.B., edited by Dom Justin McCann. Orchard Books, No. 4 (Burns Oates & Washbourne, 1924), pp. 11–13.

(senses) and all that they work in : for I tell thee truly that this work may not be conceived by them.

For by thine eyes thou mayest not conceive of anything, unless it be by the length and by the breadth, the smallness and the greatness, the roundness and the squareness, the farness and the nearness, and the colour of it. And by thine ears, nought but noise or some manner of sound. By the nose, nought but either stench or savour. And by thy taste, nought but either sour or sweet, salt or fresh, bitter or pleasant. And by the feeling, nought but either hot or cold, hard or tender, soft or sharp. And truly neither has God nor ghostly things none of these qualities nor quantities. And therefore leave thine outward wits, and work not with them, neither within nor without : for all those that set them to be ghostly workers within, and ween that they should either hear, smell, see, taste, or feel ghostly things, either within them or without, surely they are deceived and work wrong against the course of nature.

For by nature they be ordained that with them men should have knowing of all outward bodily things and in no wise by them come to the knowing of ghostly things. I mean by their works. By their failings we may, as thus : when we hear speak or read of certain things, and also conceive that our outward wits cannot tell us by any quality what those things be, then we may be verily certified that those things be ghostly things, and not bodily things.

In this same manner ghostly it fareth within in our ghostly wits when we travail about the knowing of God Himself. For have a man never so much ghostly understanding in knowing of all made ghostly things, yet may he never by the work of his understanding come to the knowing of an unmade ghostly thing : the which is nought but God. But by the failing he may. Because that thing that he faileth in is nothing else but only God. And therefore it

was that St. Denis said : ' *the most godly knowing of God is that which is known by unknowing.*' And truly whoso will look in Denis' books, he shall find that his words will clearly confirm all that I have said or shall say, from the beginning of this treatise till the end. (*The Cloud of Unknowing*, Chapter 70.)

THE PRAYERS OF A CONTEMPLATIVE

In the following passage the author shows how simple and highly spiritual the prayers of a real contemplative should be.

And right as the meditations of them that continually work in this grace and this work (of contemplation) rise suddenly without any means (without any reading or special considerations), right so do their prayers. I mean their special prayers, not those prayers that be ordained by the Holy Church. For they that be true workers in this work, they worship no prayer so much as those of Holy Church ; and therefore they do them, in the form and in the statute that they be ordained by holy fathers before us. But their special prayers rise evermore suddenly unto God, without any means or any premeditation, in special coming before, or going therewith.

And if they be in words, as they be but seldom, then be they in full few words : yea, and the fewer the better. Yea, and if it be but a little word of one syllable, methinks it is better than of two, and more according to the work of the spirit ; since a ghostly worker in this work should evermore be in the highest and the sovereignest point of the spirit. That this be truth see by ensample in the course of nature. A man or a woman, affrighted by any sudden chance of fire, or of a man's death, or whatever else it may be, suddenly in the height of his spirit he is driven in haste and in need to cry or to pray for help. Yea, how ?

Surely not in many words, nor yet in one word of two syllables. And why is that? Because he thinks it over long tarrying, for to declare the need and the work of his spirit. And therefore he bursteth up hideously with a great spirit, and crieth but one little word of one syllable : such as is this word FIRE or this word OUT. (Alas !).

And right as this little word FIRE stirreth rather and pierceth more hastily the ears of his hearers, so doth a little word of one syllable, when it is not only spoken or thought, but secretly meant in the depth of the spirit ; the which is the height : for in ghostliness all is one, height and depth, length and breadth. And rather it pierceth the ears of Almighty God than doth any long psalter unmindfully mumbled in the teeth. And therefore it is written that short prayer pierceth heaven. (*The Cloud of Unknowing.* Chapter 37, pp. 91–93.)

SUPREME DETACHMENT OF THE TRUE CONTEMPLATIVE

THAT ALL KNOWING AND FEELING OF A MAN'S OWN BEING MUST NEEDS BE LOST IF THE PERFECTION OF THIS WORK SHALL VERILY BE FELT IN ANY SOUL IN THIS LIFE.

Look that naught work in thy mind nor in thy will but only God. And try to smite down all knowing and feeling of aught under God, and tread all down full far under the *cloud of forgetting*. And thou shalt understand that in this work thou shalt forget not only all other creatures than thyself, or their deeds or thine, but also thou shalt in this work forget both thyself and thy deeds for God, as well as all other creatures and their deeds. For it is the condition of a perfect lover, not only to love that thing that he loveth,

more than himself; but also in a manner to hate himself for that thing that he loveth.

Thus shalt thou do with thyself: thou shalt loathe and be weary with all that thing that worketh in thy mind and in thy will, unless it be only God. For otherwise surely, whatsoever it be, it is betwixt thee and thy God. And no wonder if thou loathe and hate to think of thyself, when thou shalt always feel sin a foul stinking lump, thou knowest never what, betwixt thee and thy God: the which lump is none other than thyself. For thou shalt think it oned and congealed with the substance of thy being: Yea, as it were without separation.

And therefore break down all knowing and feeling of all manner of creatures, but most busily of thyself. For on the knowing and feeling of thyself hangeth the knowing and the feeling of all other creatures; for in regard of it, all other creatures be lightly forgotten. For if thou wilt busily set thee to the proof, thou shalt find, when thou hast forgotten all other creatures and all their works—yea, and also all thine own works—that there shall remain yet after, betwixt thee and thy God, a naked knowing and a feeling of thine own being: the which knowing and feeling must always be destroyed, ere the time be that thou mayest feel verily the perfection of this work. (*The Cloud of Unknowing*, Chapter 43, pp. 103–105.)

JULIAN OF NORWICH

1342-c. 1415

ALL that is known about Dame Julian is what she tells us
herself in her book of ' revelations,' with the addition of
a few details (such as her name and domicile) which
we owe to the early copiers of the manuscript. She was
probably a Benedictine nun before she went to live as a
recluse in a cell adjoining St. Julian's Church at Norwich,
where the window may still be seen whereat she assisted
at Mass.

She says in her revelations that she wished to have an
illness and to have ' bodily sight ' of our Lord's sufferings,
that she might the better share in them. Her wish was
granted, and on May 8, 1373, when she was 'thirty and
one-half years of age,' the crucified Christ appeared to
her and ' revelations ' followed one another for more than
a day without interruption, in the form of bodily and
imaginative visions, supernatural speech, and intellectual
visions—a happening probably unique in hagiology.
Julian reflected on these things for twenty years, receiving
more 'light and complementary revelations on their
meaning and significance. She seems at first to have
written a short account of them (which is extant), and
later, at least twenty years after the principal visions, she
set down the definitive results of her long contemplation in
the book of the *Revelations of Divine Love*.

These revelations can be divided into two classes. The
first is the bodily and imaginative visions, showing Jesus
on the Cross to the end that Dame Julian should have a
livelier understanding of His pains, as she had desired.
But these visions are different from those of St. Catherine
de Ricci, Anne Catherine Emmerich, and other ecstatics,
in that they were, so to say, points of departure for our
Lord's teachings and not representations of His passion
at which the visionary is merely present.

The other class of vision is intellectual, concerned ordinarily with some point of theology, and making one think in some ways of the ' Dialogues ' of St. Catherine of Siena. It was principally these that were the subject of Dame Julian's later meditations and they are the most interesting part of her book. She questions our Lord on such matters as the problem of evil, the existence of sin, predestination, an endless hell, and comments on them. She shows herself to be a deep-rooted ' optimist,' largely on account of our Lord's revelation to her of the immensity of His love. She learned from it that that love is the key to all our agonizing problems, for it is the origin and cause of all that is. Thenceforward the Redemption, the existence of evil, the possibility of sin, all such things were seen in the blazing light of Divine love and nought could trouble her, for ' all is made a bliss by love.'

Julian of Norwich is undoubtedly the most charming of English mystical writers, and perhaps the greatest. Her book stands beside those of Angela of Foligno, Catherine of Siena, and Teresa of Avila.

WORKS : *XVI Revelations of Divine Love.* Edited by Dom Serenus Cressy. First edition 1670, latest edition 1902.

The same. Modern edition edited by Dom Roger Hudleston (Burns Oates & Washbourne, 1927).

The Shewings of Lady Julian. The first version of the revelations, edited by the Rev. Dundas Harford. (London, 1925.)

JESUS OUR MOTHER

BUT now behoveth to say a little more of this forth-spreading, as I understand in the meaning of our Lord : how that we be brought again by the Mother-hood of Mercy and Grace into our Nature's place,[1] where that we were made by the Motherhood of kind Love : which Kindly-love it never leaveth us.

Our Kind Mother, our Gracious Mother,[2] for that

[1] MS. ' kyndly-stede.'
[2] i.e., our Mother by Nature, our Mother in Grace.

He would all wholly become our Mother in all things, He took the ground of His Works full low and full mildly in the Maiden's womb. (And that He showed in the First [Showing] where He brought that meek Maid afore the eye of mine understanding in the simple stature as she was when she conceived.) That is to say : our high God is sovereign Wisdom of all : in this low place He arrayed and dight Him full ready in our poor flesh, Himself to do the service and the office of Motherhood in all things.

The Mother's service is nearest, readiest, and surest : [nearest, for it is most of nature ; readiest, for it is most of love ; and surest[1]] for it is most of truth. This office none might, nor could, nor ever should do to the full, but He alone. We wit that all our mother's bearing is [bearing of] us to pain and to dying : and what is this but that our Very Mother, Jesus, He —All-Love—beareth us to joy and to endless living ?— blessed may He be ! Thus He sustaineth us within Himself in love ; and travailed, unto the full time that He would suffer the sharpest throes and the grievous-est pains that ever were or ever shall be ; and died at the last. And when He had [so] done, and so borne us to bliss, yet might not all this make full content[2] to His marvellous love ; and that showeth He in these high overpassing words of love : ' If I might suffer more, I would suffer more.'

He might no more die, but He would not stint of working : wherefore then it behoveth Him to feed us ; for the dearworthy love of Motherhood hath made Him debtor to us. The mother may give her child suck [of] her milk, but our precious Mother, Jesus, He may feed us with Himself, and doeth it, full courteously and full tenderly, with the Blessed Sacrament that is precious food of very life ; and with all the sweet Sacraments He sustaineth us full mercifully

[1] These clauses, omitted from the MS., are in Cressy's version.
[2] MS. ' makyn asseth.'

and graciously. And so meant He in this blessed word where that He said : ' I it am that Holy Church preacheth thee and teacheth thee.' That is to say : ' All the health and life of Sacraments, all the virtue and grace of My Word, all the Goodness that is ordained in Holy Church for thee, I it am.' The Mother may lay the child tenderly to her breast, but our tender Mother, Jesus, He may homely lead us into His blessed breast, by His sweet open side, and show therein part of the Godhead and the joys of Heaven, with ghostly sureness of endless bliss. And that showed He in the Tenth [Showing], giving the same understanding in this sweet word where He saith : ' Lo ! how I loved thee'; beholding into His side, rejoicing.

This fair lovely word *Mother*, it is so sweet and so kind itself[1] that it may not verily be said of none but of Him ; and to her that is very Mother of Him and of all. To the property of Motherhood belongeth kind love, wisdom, and knowing ; and it is good : for though it be so that our bodily forthbringing be but little, low, and simple in regard of our ghostly forthbringing, yet it is He that doeth it in the creatures by whom that it is done. The Kind, loving Mother that witteth and knoweth the need of her child, she keepeth it full tenderly, as the kind and condition of Motherhood will. And as it waxeth in age, she changeth her working, but not her love. And when it is waxen of more age, she suffereth that it be beaten[2] in breaking down of vices, to make the child receive virtues and graces. This working, with all that be fair and good, our Lord doeth it in them by whom it is done : thus He is our Mother in kind by the working of Grace in the lower part for love of the higher part. And He willeth that we know this : for He will have all our love fastened to Him. And in this I saw that all our duty that we owe, by God's

[1] MS. ' so kynd of the self.' [2] MS. ' brinstinid.'

bidding, to Fatherhood and Motherhood, for [reason of] God's Fatherhood and Motherhood is fulfilled in true loving of God ; which blessed love Christ worketh in us. And this was showed in all [the Revelations] and especially in the high plenteous words where He saith : ' It is I that thou lovest.'

THE USE OF FAULTS

AND after this He suffereth some of us to fall more hard and more grievously than ever we did afore, as us thinketh. And then ween we (who be not all wise) that all were naught that we have begun. But it is not so. For it needeth us to fall, and it needeth us to see it. For if we never fell, we should not know how feeble and how wretched we are of our self, and also we should not fully know that marvellous love of our Maker. For we shall see verily in heaven, without end, that we have grievously sinned in this life, and notwithstanding this, we shall see that we were never hurt in His love, nor were never the less of price in His sight. And by the assay of this falling we shall have an high, marvellous knowing of love in God, without end. For hard and marvellous is that love which may not, nor will not, be broken for trespass. And this is one understanding of profit. Another is the lowness and meekness that we shall get by the sight of our falling : for thereby we shall highly be raised in heaven ; to which raising we might[1] never have come without that meekness. And therefore it needeth us to see it ; and if we see it not, though we fell it should not profit us. And commonly, first we fall and later[2] we see it : and both of the Mercy of God.

The mother may suffer the child to fall sometimes, and be dis-eased in diverse manners for its own profit, but she may never suffer that any manner of peril

[1] i.e., could. [2] MS. ' syth.'

come to the child, for love. And though our earthly mother may suffer her child to perish, our heavenly Mother, Jesus, may not suffer us that are His children to perish : for He is All-Mighty, All-wisdom, and All-love ; and so is none but He—blessed may He be !

But oftentimes when our falling and our wretchedness is showed us, we are so sore adread, and so greatly ashamed of our self, that scarcely we wit where we may hold us. But then willeth not our courteous Mother that we flee away, for Him were nothing lother. But He willeth then that we use the condition of a child : for when it is dis-eased, or adread, it runneth hastily to the mother for help, with all its might. So willeth He that we do, as a meek child saying thus : ' My kind Mother, my Gracious Mother, my dearworthy Mother, have mercy on me : I have made myself foul and unlike to thee, and I nor may nor can amend it but with thy privy help and grace.' And if we feel us not then eased forthwith, be we sure that He useth the condition of a wise mother. For if He see that it be more profit to us to mourn and to weep, He suffereth it, with ruth and pity, unto the best time, for love. And He willeth then that we use the property of a child, that evermore kindly trusteth to the love of the mother in weal and in woe.

JESUS CRUCIFIED

And in this dying was brought to my mind the words of Christ : ' *I thirst.*'

For I saw in Christ a double thirst : one bodily ; another ghostly, the which I shall speak of in the Thirty-first Chapter.

For this word was showed for the bodily thirst : the which I understood was caused by failing of moisture. For the blessed flesh and bones was left all alone without blood and moisture. The blessed body

dried alone long time, with wringing of the nails and
weight of the body. For I understood that, for
tenderness of the sweet hands and of the sweet feet,
by the greatness, hardness, and grievousness of the
nails the wounds waxed wide and the body sagged,
for weight by long time hanging. And [therewith
was] piercing and wringing of the head, and binding
of the Crown all baked with dry blood, with the sweet
hair clinging, and the dry flesh, to the thorns, and the
thorns to the flesh drying ; and in the beginning
while the flesh was fresh and bleeding, the continual
sitting of the thorns made the wounds wide. And
furthermore I saw that the sweet skin and the tender
flesh, with the hair and the blood, was all raised and
loosed about from the bone, with the thorns where-
through it were digged in many pieces, as a cloth
that were sagging, as if it would hastily have fallen
off, for heaviness and looseness, while it had natural[1]
moisture. And that was great sorrow and dread to
me : for methought I would not for my life have
seen it fall. How it was done I saw not ; but under-
stood it was with the sharp thorns and the boisterous
and grievous setting on of the Garland [of Thorns]
unsparingly and without pity. This continued awhile,
and soon it began to change, and I beheld and
marvelled how it might be. And then I saw it was
because it began to dry, and stint a part of the weight,
and set about the Garland. And thus it environed
all about, as it were garland upon garland. The
Garland of the Thorns was dyed with the blood, and
the other garland [of Blood] and the head, all was one
colour, as clotted blood when it is dry. The skin of
the flesh that showed of the face and of the body, was
small-wrinkled with a tanned colour, like a dry board
when it is skinned ;[2] and the face more brown than
the body.

 I saw four manner of dryings : the first was bloodless ;

[1] MS. ' kind.' [2] i.e., when the bark is stripped off.

the second was pain following after ; the third, hanging
up in the air, as men hang a cloth to dry ; the fourth,
that the bodily kind asked liquor and there was no
manner of comfort ministered to Him in all His woe
and dis-ease. Ah ! hard and grievous was His pain,
but much more hard and grievous it was when the
moisture failed and all began to dry thus clinging.

These were the pains that showed in the blessed
head : the first wrought to the dying, while it was
moist ; and that other, slow, with clinging drying,
with blowing of the wind from without, that dried
and pained Him with cold more than mine heart
can think.

And other pains—for which pains I saw that all is
too little that I can say : for it may not be told.

The which Showing of Christ's pains filled me full
of pain. For I wist well He suffered but once, but
[this was as if] He would show it me and fill me with
mind as I had afore desired. And in all this time of
Christ's pains I felt no pain but for Christ's pains.
Then thought-me : ' I knew but little what pain it
was that I asked ' ; and, as a wretch, repented me,
thinking : ' If I had wist what it had been, loth me
had been to have prayed it.' For methought it passed
bodily death, my pains.

I thought : ' Is any pain like this ? ' And I was
answered in my reason : ' Hell is another pain : for
there is despair. But of all pains that lead to salvation
this is the most pain, to see thy Love suffer. How
might any pain be more to me than to see Him that
is all my life, all my bliss, and all my joy, suffer ? '
Here felt I soothfastly[1] that I loved Christ so much
above myself that there was no pain that might be
suffered like to that sorrow that I had to see Him in
pain.

[1] i.e., in truth.

THE SOUL'S TRUE REST

IN this same time our Lord showed me a ghostly sight of His homely loving.

I saw that He is to us everything that is good and comfortable for us. He is our clothing that for love wrappeth us, claspeth[1] us, and all becloseth us for tender love, that He may never leave us ; being to us all-thing that is good, as to mine understanding.

Also in this He showed [me] a little thing, the quantity of an hazel-nut, in the palm of my hand ; and it was as round as a ball. I looked thereupon with eye of my understanding, ánd thought : ' What may this be ? ' And it was generally answered thus : ' It is all that is made.' I marvelled how it might last, for methought it might suddenly have fallen to naught for little[ness]. And I was answered in my understanding : ' It lasteth, and ever shall [last] for that God loveth it.' And so all thing hath the Being by the love of God.

In this Little Thing I saw three properties. The first is that God made it : the second is that God loveth it : the third, that God keepeth it. But what is to me soothly the Maker, the Keeper, and the Lover,—I cannot tell ; for till I am substantially oned[2] to Him, I may never have full rest nor very bliss : that is to say, till I be so fastened to Him, that there is right naught that is made betwixt my God and me.

It needeth us to have knowing of the littleness of creatures and to naughten[3] all thing that is made, for to love and have God that is unmade. For this is the cause why we be not all in ease of heart and soul : that we seek here rest in those things that be so little, wherein is no rest, and know not our God that is

[1] MS. ' halfyth us.' [2] i.e., united.
[3] i.e., to make naught of.

Almighty, All-wise, All-good. For He is the Very Rest. God will[eth to] be known, and it liketh Him that we rest in Him ; for all that is beneath Him sufficeth not us. And this is the cause why that no soul is rested till it is naughted of[1] all things that are made. When it is wilfully naughted, for love to have Him that is all, then is it able to receive ghostly rest.

Also our Lord God showed that it is full great pleasance to Him that a silly soul come to Him nakedly and plainly and homely. For this is the kind yearnings of the soul, by the touching of the Holy Ghost (as by the understanding that I have in this Showing). 'God, of Thy Goodness, give me Thyself: for Thou art enough to me, and I may nothing ask that is less, that may be full worship to Thee ; and if I ask anything that is less, ever me wanteth—but only in Thee I have all.'

And these words are full lovesome to the soul, and full near touch they the will of God and His Goodness. For His Goodness comprehendeth all His creatures and all His blessed works, and overpasseth[2] without end. For He is the endlessness, and He hath made us only to Himself, and restored us by His blessed Passion, and keepeth us in His blessed love ; and all this is of His Goodness.

IN SPITE OF SIN ALL SHALL BE WELL

THE two following passages give us an example of Dame Julian's theological difficulties. To her difficulty about the existence of sin, our Lord answers indirectly by the famous words ' all shall be well, and all shall be well, and all manner of things shall be well.'

' And after this our Lord brought to my mind the longing that I had to Him before ; and I saw nothing

[1] i.e., emptied of, detached from. [2] i.e., surpasseth.

letted me but sin. And so I beheld generally in us
all (etc. . . . till the end of the chapter. In the edition
of Father Tyrrell it is Chapter 27, 13th revelation).

 ' But in this I stood beholding generally, sweinly
and mourningly, saying thus to our Lord' (etc. . . .
till the end of the chapter. In the edition of Father
Tyrrell it is Chapter 29, 13th revelation).

ST. CATHERINE OF SIENA
1347-1380

CATHERINE was the youngest but one of the twenty-five children of a dyer, Graciomo di Benincasa. From very early childhood she was a visionary and practised austerities, and later on resolutely refused to think of marriage, to the annoyance of her parents. She lived as a recluse in her father's house for a time, at the age of sixteen became a secular Dominican tertiary, and later rejoined her family. She had already experienced many visions and other mystical experiences, consolatory and frightening, and in 1366 was spiritually wedded to our Lord, who told her to undertake a life of active apostolate. She began by attempting to calm the civil strife of her native city, counselling the magistrates and party leaders and looking after the captives and casualties.

Catherine's influence became enormous and she was known through Italy. A 'spiritual family' gathered round her : men and women of all ranks, clerics and lay people, who called her 'mother' and alternately helped and bothered her. In 1375 she received the *stigmata*, but invisibly at her own prayer, and in the following year she went to Pope Gregory XI at Avignon and succeeded—where so many had failed—in persuading him to return to Rome. His successor, Urban VI, summoned Catherine to Rome as his counsellor, in 1378, and there she died two years later, offering her life for the peace of the Church that was already being torn by the 'great schism.'

TRANSLATIONS : *The Dialogue of the Seraphic Virgin St. Catherine of Siena.* Translated by Algar Thorold (Burns Oates & Washbourne, 1925).

Life of St. Catherine of Siena. By Alice Curtayne. (London, 1931.)

THE ATTAINMENT OF PERFECT LOVE

Catherine : I know, Lord, that Your will and my perfecting are to be sought in the sovereign love of Yourself, so I want to fulfil this righteousness and to love You with this sovereign love as ardently as I may. But how must I set about it ? I do not understand that sufficiently and I beseech You to enlighten me more.

Our Lord : Listen attentively with your whole mind. To love Me perfectly three things are necessary.

In the first place : To purify and direct the will in its temporal loves and bodily attachments so that nothing passing and perishable is loved except because of Me. The important thing is not to love Me for your own sake, or yourself for your own sake, or your neighbour for your own sake, but to love Me for Myself, yourself for Myself, your neighbour for Myself. Divine love cannot suffer to share with any earthly love, and you lack in perfection and transgress My love in the measure that you let temporal things detract from it. In order to be disinterested and holy the soul should be averse from what is pleasing to the body. Behave in such a way that the created things I have given to you as a means to warm and increase your love should do so, and not have the contrary effect of hindering it. I have made and given them to you that you should learn a better idea of My limitless goodness therefrom and so love Me yet more. Pull yourself together, then ! Gird up your loins, control your senses, be careful, master the unruliness of the desires which the conditions of mortal life and the defect of human nature raise on every side, so that you may be able to say with the prophet, ' O thou who hast formed my feet '—that is, my affections, which are the feet of the soul, ' like those of the deer '—to run from the hounds, the dangerous

deceits of inordinate desires, ' Thou shalt set me in an high place '—namely, contemplation.

In the second place : When you have reached the first stage, you will be able to go on to the second, which needs a greater perfection. Take My honour and My glory as the sole end of your thoughts, your actions, and all that you do ; try always to worship Me, whether it be by prayer, by words, or by deeds ; do all you can to help your neighbour to have the same state of mind, so that everyone you meet may know, love, and worship Me like you and with you. This doing will be yet more pleasing to Me, for by it My purpose will be more advanced.

In the third place : If you do that which I am going to tell you now, you will have reached a consummate perfection and nothing will be wanting in you. It is the attainment of an ardently desired and perseveringly sought disposition of the soul in which you are so closely united with Me and your will so conformed to My perfect will that you never wish not only evil, but even the good that I do not wish ; in every circum-stance of this wretched life, whether spiritual or temporal interests are involved, whatever the diffi-culties, you possess your soul in peace and quietness, having always an unshakeable faith in Me, your Almighty God, knowing that I can love you more than you can love yourself and that I watch over you a thousand times more carefully than you can watch over yourself. The more trustfully you give yourself up to Me, the more I shall be watching over you ; you will gain a clearer knowledge of Me and experience My love more and more delightfully.

Such perfection can be reached only by a steady, continuous, and absolute renunciation of self-will. To refuse this renunciation is to refuse true perfection. He who renounces willingly by the same act does My will perfectly ; his life is pleasing to Me and I am with him, for I love above all to dwell in mankind

and work in them by grace—' My delight is to be with the children of men.' I must not infringe the rights of your freedom ; but I will transform you in Myself, since you wish it, and make you one with Me by making you share in My perfection, particularly in My tranquillity and My peace. (*Dialogue sur la Perfection*, tr. par R. P. Bernadot, O.P.)

DIVINE PROVIDENCE

How blind they are who do not see that everything which God allows to happen is ordained for our good and our salvation.

' I want to make you see, My well-beloved daughter, what patience I have to exercise in sustaining the creatures which I have made most lovingly (as I have told you) in My own image and likeness. Open the eyes of your understanding and look at Me. . . .'

Thereupon this soul turned the eyes of her mind, enlightened by the light of our most holy Faith, and fixed them upon the Divine Majesty with burning desire, for the words she had heard had taught her better to understand the truth of God's good providence. Obeying His word, she looked into the abyss of charity, and there saw how He was the sovereign and eternal Goodness, how for love He created and then redeemed us by the blood of His Son, and how this same love was the source of all His many gifts to us, whether sufferings or joys. All comes from love, and all God does is ordered toward the salvation of mankind. That is the truth that she saw in the Blood poured out with such a lavishness of love.

Then the eternal and all-governing Father said to her :

' Those who are indignant at and rebel against the things that befall them are blind with self-love. I speak to you now in general and in particular, and

I say that they take for evil and regard as misfortunes, ruin, evidence of hate towards themselves, the things that I do out of love and for their good, that they may be saved from eternal loss and receive the life which shall not pass away. Why then do they murmur against Me ? Because they have put their trust in themselves, and so all becomes dark for them and they do not know things as they are : wherefore they hate what they should reverence and in their pride would judge My secret judgements which are righteousness itself. They are like blind men who try by touch or by taste or by hearing to appraise the worth of things that cannot be estimated by those senses alone. They will not turn to Me, the true light, Who feeds their souls and their bodies, without Whom they are not. When somebody does something for them it is I who have prompted the deed and given that creature the ability and knowledge and will to do them that service. These foolish people want to rely only on what they can feel with their hands. But touch is deceptive : it lacks light, whereby colour may be discerned ; nor can taste alone be trusted, for it does not see the noxious germ upon the food ; the ear can be misled by a sweet sound, because it does .not see the singer, and trusting in the voice alone you may come upon death.

' So it is with these blind folk who have lost the light of reason fulfilled by faith : they will believe only the evidence of their senses, like him who tests a thing with his hands alone. The pleasures of the world seem lovely to them : but as they do not really see them they do not take into account that these pleasures are like a piece of good cloth that is full of thorns, that much grief and many cares wait upon them, and that the heart that cherishes them without reference to Me cannot bear the burden of itself. These pleasures seem to have a good taste to the mouth, that is, to an inordinate desire for them, but

they are alive with foul microbes, a swarm of deadly sins that infect the soul, deprive her of the life of grace, and so disfigure her that she loses her likeness to Me.

'They listen to the voice of self-love, and think what a nice sound they hear. And why? Because the soul, left to herself, makes a bee-line for self-indulgence and is all ears for the song that betrays her; she troubles about nothing else, but follows the entrancing voice that leads to ruin; then she falls into the ditch, the nets of sin entangle her, and she is in the hands of her enemies. I was no longer anything to her, I, her guide and her path; she was blinded with self-love, with confidence in her own powers and her own knowledge. The path has been shown to her by My Son, the Word, when He said, "I am the way, the truth, and the life." Whoever walks in it cannot lose his way or be overtaken by darkness, nor can any come to Me except through Him, for He and I are one. I have already told you that I have made of My Son a bridge over which all may come to their proper end, but for all that men will not trust Me, although I am concerned only for their sanctification. My great love ordains or permits everything that happens to that end alone—and they are always shocked at me. I bear with them patiently and protect them, for I love them even though they do not love Me—and they unrelentingly return Me revolt, hate, complaints, endless unfaithfulness. They do not even know themselves, and yet in their blindness they want to see the most secret purposes that I ordain in justice and love. But he who does not know himself cannot truly know Me or understand My judgements; and all things else he sees distortedly.' (*Le dialogue de Ste. Catherine*, tr. par R. P. Hurtaud, O.P., Paris, 1931, t. II, pp. 160–164.)

THE STATE OF PERFECT SOULS

SUCH ones thirst after suffering and are ceaselessly conscious of the Divine presence.

' Now I have told thee how it is to be seen that souls have arrived at the perfection of love, friendly and filial. Now I do not want to conceal from thee how great is the delight with which they taste Me, though they are still in the mortal body. This is because, having arrived at the third state, they acquire the fourth, which, however, is not separated from the third, but is united with it, and the one cannot be without the other, except in the same way as love of Me can be without love of the neighbour. A fruit that arises from this third condition of the soul's perfect union with Me, wherein she acquires fortitude, is that not only does she bear with patience, but she anxiously desires to suffer pain for the glory and praise of My name. Such as these glory in the shame of My only-begotten Son, as said Paul, my standard-bearer : " *I glory in tribulations, and in the shame of Christ crucified* " —and in another place—" *God forbid that I should glory save in Christ crucified* "—and again—" *I bear in my body the stigmata of Christ crucified.*" Such as these, I say, as if enamoured of My honour, and famished for the food of souls, run to the table of the most Holy Cross, willing to suffer pain and endure much of the service of the neighbour, and desiring to persevere and acquire the virtues, bearing in their body the stigmata of Christ crucified, causing the crucified love which is theirs to shine, being visible through self-content and delighted endurance of the shames and vexations on every side. To these, My most dear sons, trouble is a pleasure, and pleasure and every consolation that the world would offer them are a toil, and not only the consolation that the servants of the world, by My dispensation, are constrained to give

them, in reverence and in compassion of their corporal necessities, but also the mental consolation which they receive from Me, the eternal Father. Even this they despise through humility and self-hatred. They do not despise consolation itself, which is My gift and grace, but only the pleasure which the soul's appetite finds therein. And this they do through the virtue of true humility, obtained through holy self-hatred, which is the nurse and nourisher of love, and has been acquainted through true knowledge of themselves and of Me. Wherefore, as thou seest, the virtues and wounds of Christ crucified shine in their bodies and souls. Such as these do not feel any separation from Me, as happens in the case of others, of whom I have told you, namely, that I would leave them, not by grace, but by feeling, afterwards returning to them again. I do not act thus to these most perfect ones who have arrived at the great perfection, and are entirely dead to their own wills, but I remain continually both by grace and feeling in their soul, so that at any time that they wish they can unite their mind to Me, through love. They can in no way be separated from My love, for, by love, they have arrived at so close a union. Every place is to them an oratory, every moment a time for prayer—their conversation has ascended from earth to heaven— that is to say, they have cut off from themselves every form of earthly affection and sensual self-love, and have risen alone themselves into the very height of Heaven, having climbed the staircase of virtues and mounted the three steps which I figured to thee, in the body of My Son.'

ECSTATIC UNION

GOD often tempers the vehemence of His union with the chosen soul, without withdrawing consciousness of His presence.

' I have said that, from these perfect ones, I never
withdraw by sentiment. But in another way I depart
from them, for the soul, being bound in the body, is
not sufficient continually to receive that union which
I make with her, and because she is not sufficient,
I withdraw Myself, not by sentiment or by grace,
but by that union which I make with her. For souls,
arising with anxious desire, run, with virtue, by the
capital bridge of the doctrine of Christ crucified, and
arrive at the gate, lifting up their minds in Me, and in
the blood, and burning with the fire of love they taste
in Me, the eternal Deity, Who am to them a sea
pacific, with Whom the souls have made so great
union, and she has no movement except in Me. And,
being yet mortal, they taste the good of the immortals,
and having yet the weight of the body, they receive
the joy of the spirit. Wherefore oftentimes, through
the perfect union which the soul has made with Me,
she is raised from the earth almost as if the heavy
body became light. But this does not mean that
the heaviness of the body is taken away, but that the
union of the soul with Me is more perfect than
the union of the body with the soul ; wherefore the
strength of the spirit, united with Me, raises the weight
of the body from the earth, leaving it as if immovable
and all pulled to pieces in the affection of the soul.
Thou rememberest to have heard it said of some
creatures, that were it not for My goodness, in seeking
strength for them, they would not be able to live,
and I would tell thee, that, in the fact that the souls
of some do not leave their bodies is to be seen a greater
miracle than in the fact that some have arisen from
the dead, so great is the union which they have with
me. I, therefore, sometimes for a space withdraw
from the union, making the soul return to the vessel
of her body, that is, to the sentiment of the body,
from which she was separated through the affection
of love. From the body she did not depart, because

that cannot be, except in death ; the bodily powers alone departed, becoming united to Me through affections of love. The memory is full of nothing but Me ; the intellect, elevated, gazes upon the object of My Truth ; the affection, which follows the intellect, loves and becomes united with that which the intellect sees. These powers, being united and gathered together and immersed and inflamed in Me, the body loses its feeling, so that the seeing eye sees not, and the hearing ear hears not, and the tongue does not speak, except as the abundance of the heart will sometimes permit it for the alleviation of the heart and the praise and glory of My name.

'The hand does not touch and the feet walk not because the members are bound with the sentiment of love, and, as it were, contrary to all their natural functions, cry to Me, the Eternal Father, for the separation of the soul from the Body, as did My glorious Paul, saying : " *O wretched man that I am, who will separate me from this body ? for I feel within me a perverse law which wars against the Spirit.*" Paul was not referring to the warring of senses against the Spirit, from which he knew he was secured by My words : *My grace is sufficient for thee.* Why then did he utter those words for Me ? Because he found himself bound in the vessel of the body, which for a space of time impeded his vision of Me. That is to say, until death, his eyes were bound so as not to be able to see Me, the Eternal Trinity, who am in the sight of the blessed immortals, who render praise and glory to My name. Whereas he found himself in the midst of mortals who always offend Me, deprived of the sight of Me, that is, of Me in My essence.'

WALTER HILTON

d. 1396

LITTLE enough is known of the life of Walter Hilton.
For a long time he was supposed to have been a Carthusian
monk, but he was in fact an Austin canon regular at
Thurgarton in Nottinghamshire, where he died on March
24, 1396. He was a great friend of the Carthusians, who
in turn admired him, and his writings, which within a
hundred years of his death were known throughout
England, France, and neighbouring countries, were
passed on from charterhouse to charterhouse.

His principal work is *The Ladder of Perfection*, which was
printed by Wynkyn de Worde in 1494, a systematic
treatise written for a nun who was probably an anchoress.
It covers the whole spiritual life, showing what is required
in preparation for the life of union with God in contempla-
tion, of which a masterly analysis is presented. The
Ladder may be called, in a figure of speech that is continually
suggested by it, a ' guide-book ' for the journey to the
spiritual Jerusalem, namely, the ' contemplation in perfect
love of God.'

Hilton wrote two other treatises of less importance,
which were both printed early in the sixteenth century.
One, *To a Devout Man in Temporal Estate*, contains spiritual
counsels for a layman of high rank ; the other, *The Song
of Angels*, is more specifically mystical and describes the
heavenly delights enjoyed by the purified soul. Other
treatises are attributed to Hilton, most of which are still
unpublished, and his reputation was so great in England
during the fifteenth century that he was accepted as the
author of the *Imitation of Christ*. His style of writing has
not the attractiveness of that of the author of *The Cloud*

of Unknowing or of Dame Julian and lacks the poetical imagery and warmth of Rolle ; on the other hand, he is clear and methodical, displaying theological profundity and a wide knowledge of the Bible, St. Augustine, St. Gregory, St. Bernard, and above all of St. Thomas and the scholastics. Hilton was more widely known and appreciated than his predecessors, and his *Ladder of Perfection* in particular was a powerful influence during the fifteenth century, especially in the formation of religions.

WORKS : *The Scale of Perfection*. With an introduction by Dom M. Noetinger (Burns Oates & Washbourne, 1927).

The Minor Works of Walter Hilton. Edited by Dorothy Jones (Burns Oates & Washbourne, 1931).

THE PARABLE OF A DEVOUT PILGRIM

THE most famous passage of *The Ladder of Perfection* is surely the one in which Hilton, under the parable of a pilgrim going to Jerusalem, describes the various difficulties which a devout soul has to overcome before reaching the city of peace, viz. the blessed state of union with God in loving contemplation. Father Baker did not hesitate to reproduce the whole passage (three chapters) somewhat paraphrased in his *Sancta Sophia*. We give here the second and third chapter.

Now thou art in the way, and wottest how thou shalt go. Now beware of enemies that will be busy to let thee if they may. For their intent is to put out of thine heart that desire and the longing thou hast to the love of Jesus, and to drive thee home again to the love of worldly vanities, for there is nothing that grieves them so much. These enemies are principally fleshly desires and vain dreads, that rise out of thy heart through corruption of thy fleshly kind, and would let they desire of the love of God, that they might

fully and restfully occupy thine heart ; these are thy next enemies. Also other enemies there be, as unclean spirits that are busy with sleights and wiles to deceive thee. But one remedy shalt thou have that I said before ; whatsoever it be that they say, trow them not, but hold forth thy way and only desire the love of Jesus. Answer ever thus : I am naught, I have naught, I covet naught, but only the love of Jesus.

If thine enemies say to thee first thus, by stirrings in heart, that thou art not shriven aright, or that there is some old sin hid in thy heart that thou knowest not, nor never were shriven aright, and therefore thou must turn home again and leave thy desire (of going to Jerusalem) and go shrive thee better : trow not this saying for it is false, for thou art shriven. Trust securely that thou art in the way, and needest no more ransacking of shrift for that which is past. Hold forth thy way and think on Jerusalem.

Also if they say that thou art not worthy to have the love of God, whereto shalt thou covet that thou might not have, nor art not worthy thereto ; trow them not, but go forth and say thus : ' Not because I am worthy, but because I am unworthy, therefore would I love God ; for if I had it, that would make me worthy. And since I was made thereto, though I should never have it, yet will I covet it, and therefore will I pray and think that I might get it.'

And then if thine enemies see that thou beginnest to wax bold and well willed to thy work, they begin to wax afraid of thee. Nevertheless they will not cease from tarrying thee whenever they may, as long as thou art going on the way, what with dread and menacing on the one side, what with flattering and false pleasing on the other side, to make thee break thy purpose and turn home again. They will say thus : If thou hold forth thy desire to Jesus so fully

travailing as thou beginnest, thou shalt fall into sickness or into fantasies, or into frenzies, as thou seest that some do ; or thou shalt fall into poverty and bodily mischief ; and no man shall well help thee. Or thou might fall into privy temptations of the fiend, that thou shalt not help thyself. For it is wonderful perilous to any man to give him fully to the love of God, and leave all the world, and covet nothing, but only the love of Him ; for so many perils may befall that a man knoweth not of. And therefore turn home again and leave this desire, for thou shalt never bring it to the end ; and do as other worldly men do.

Thus say thine enemies, but trow them not, but hold forth thy desire and say naught else, but thou wouldest have Jesus, and be at Jerusalem. And if they perceive then thy will so strong that thou wilt not spare neither for sin nor for sickness, for fantasies nor for frenzies, for doubts nor for dreads of ghostly temptations, for mischief nor for poverty, for life nor for death ; but ever forth thou wilt one thing and nothing but one, and makest deaf ear to them as though thou heard them not, and holdest thee forth stiffly in thy prayer and in thy other ghostly works without stinting, with discretion after the counsel of thy sovereign (superior) or of thy ghostly father, then begin they to be wroth and go a little nearer thee. Then they begin to rob thee and beat thee, and do thee all the shame they can. And that is when they bring it to pass that all the deeds that thou dost, be they never so well done, are deemed of other men as ill and turned into the worst part. And whatsoever it be that thou wouldest have done in help of thy body or of thy soul, it shall be letted or hindered by other men ; so that thou shalt be put from thy will in all things that thou skilfully covetest. And all this they do that thou shouldest be stirred to ire or melancholy or evil will against thy even-Christian. But against all these dis-eases, and

all other that thou mayest feel, use this remedy. Take Jesus in thy mind, and anger thee not with them, tarry not with them, but think on thy lesson, that thou art naught, that thou hast naught, that thou mayest naught lose of earthly good, thou covetest naught but the love of Jesus, and hold forth thy way to Jerusalem with thy occupation.

And nevertheless if thou be tarried sometime through frailty of thyself with such uneases as fall to thy bodily life, through evil will of man or malice of the fiend, as soon as thou mayest come again to thyself, leave off the thinking of thy dis-ease and go forth to thy work. Abide not too long with them for dread of thine enemies.

And after this, when thine enemies see that thou art so well willed . . . then they are much abashed. But then will they assay thee with flattering and vain pleasing. And that is when they bring to the sight of thy soul all thy good deeds and virtues, and bear upon thee that all men praise thee and speak good of thy holiness, and how all men love thee and worship thee for thy holy living. Thus do thine enemies that thou shouldst think their saying sooth, and have delight in this vain joy and rest thee therein. But if thou do well, thou shalt hold all such jangling as falsehood and flattery of thine enemy, that proffereth thee to drink venom tempered with honey, and therefore refuse it and say thou wilt not thereof, but thou wouldest be at Jerusalem.

Such lettings thou shalt feel or else other like unto them, what of thy flesh, what of the world, what of the fiend more than I can rehearse now. For a man as long as he suffereth his thought wilfully to run about the world in beholding of sundry things, he perceiveth few lettings, but as soon as he draws all his thought and his yearning to one thing only, to have that, to know that, to love that, and that is only Jesus, then shall he feel many painful lettings, for

everything that he feels which is not that that he covets
is letting to him.

Therefore I have told thee of some specially, as
for example ; and overmore I say generally that what
stirring that thou feelest of thy flesh or of the fiend,
pleasant or painful, bitter or sweet, liking or dreadful,
gladsome or sorrowful, that would draw down thy
thought and thy desire from the love of Jesus, to
worldly vanity, and would let utterly thy ghostly
covetousness that thou hast to the love of Him, and
that thy heart should be occupied with that stirring
restingly, set it at naught, receive it not wilfully, tarry
not therewith too long.

But if it be of some worldly thing that behoveth
needs to be done to thyself or to thine even-Christian,
speed thee soon of it and bring it to an end, that
it hang not on thy heart. If it be another thing that
needeth not, or else that toucheth thee not, charge it
not, jangle not therewith, nor anger thee not, dread
it not, like it not, but smite it out of thine heart readily,
and say thus : ' I am naught, I have naught, naught
I seek nor covet, but the love of Jesus.'

Knit thy thought to this desire, and strengthen it
and maintain it with prayer and with other ghostly
works that thou forget it not, and it shall lead thee in
the right way and save thee from all perils, and though
thou feel them, thou shalt not perish, and I hope that
it shall bring thee to perfect love of our Lord Jesus.

Nevertheless on the other side I say also, what work
or what stirring it may be that may help thy desire,
and make thy thought furthest from lust and mind
of the world, more whole and more burning to the love
of God, strengthen it and nourish it ; whether it be
praying or thinking ; whether stillness or speaking,
reading or hearing, loneliness or communing, going
or sitting ; keep it for the time and work therein as
long as the savour lasteth, if it so be that thou take
therewith meat and drink and sleep as a pilgrim doth,

and keep discretion in thy working after counsel and
ordinance of thy sovereign. For have he never so
great haste in his going, yet will he eat and drink and
sleep. Do thou likewise. For though it let thee one
time, it shall further thee another time.

ST. CATHERINE OF GENOA

1447–1510

THE family of Fieschi into which Catherine was born was a very distinguished one which had given two popes to the Church and several illustrious men to Italy ; her father had been viceroy of Naples. At sixteen she was married to William Adorno, a bad-tempered and un-scrupulous young man who led his wife an awful life. She moped for five years and for another five tried to distract herself in social life, till one day in 1474, while she was preparing for confession, she had a sudden vision in which she saw her own sinfulness and God's goodness so clearly that she lost consciousness on the spot. There-upon she made a general confession, subjected herself to rigorous penance, and after a time was admitted to daily communion.

For fifteen years Catherine had frequent visions and revelations, her contemplation being joined to tireless work for the poor and sick ; she helped to found an association to visit them in their homes, the members wearing a mask so as not to cause embarrassment to the sensitive. She reformed her husband before his death in 1497, and herself died thirteen years later after many grievous trials and sufferings.

The treatise on Purgatory of Catherine of Genoa is one of the most famous works on the subject, and she wrote a dialogue between the soul and the body in which she treats allegorically of mankind, the spirit, self-love, our Lord, and so on.

TRANSLATIONS : *Dialogue entre l'âme et le corps. On Purgatory* (Burns Oates & Washbourne, New Edition, 1929).

THE SOULS IN PURGATORY

THE souls in purgatory, as far as I can understand the matter, cannot but choose to be there ; and this by God's ordinance, who has justly decreed it so. They cannot reflect within themselves and say, ' I have done such and such sins, for which I deserve to be here ' ; nor can they say, ' Would that I had not done them, that now I might go to Paradise ' ; nor yet say, ' That soul is going out before me ' ; nor, ' I shall go out before him.' They can remember nothing of themselves or others, whether good or evil, which might increase the pain they ordinarily endure ; they are so completely satisfied with what God has ordained for them, that He should be doing all that pleases Him, and in the way it pleases Him, that they are incapable of thinking of themselves even in the midst of their greatest sufferings. They behold only the goodness of God, Whose mercy is so great in bringing men to Himself, that they cannot see anything that may affect them, whether good or bad ; if they could, they would not be in pure charity. They do not know that their sufferings are for the sake of their sins, nor can they keep in view the sins themselves ; for in doing so there would be an act of imperfection, which could have no place where there can be no longer any possibility of actually sinning.

Once, in passing out of this life, they perceive why they have their purgatory ; but never afterwards, otherwise self would come in. Abiding, then, in charity, and not being able to deviate therefrom by any real defect, they have no will, no desire, nothing but the will of pure love ; they are in that fire of purgatory by the appointment of God, which is all one with pure love ; and they cannot in anything turn aside from it, because, as they can no more merit, so they can no more sin.

JOYS AND SUFFERINGS OF PURGATORY

I DO not believe it would be possible to find any joy comparable to that of a soul in purgatory, except the joy of the blessed in Paradise—a joy which goes on increasing day by day, as God more and more flows in upon the soul, which He does abundantly in proportion as every hindrance to His entrance is consumed away. The hindrance is the rust of sin ; the fire consumes the rust, and thus the soul goes on laying itself open to the Divine inflowing.

It is as with a covered object. The object cannot respond to the rays of the sun, not because the sun ceases to shine—for it shines without intermission— but because the covering intervenes. Let the covering be destroyed, again the object will be exposed to the sun, and will answer to the rays which beat against it in proportion as the work of destruction advances. Thus the souls are covered by a rust—that is, sin which is gradually consumed away by the fire of purgatory ; the more it is consumed, the more they respond to God, their true Sun ; their happiness increases as the rust falls off, and lays them open to the Divine ray ; and so their happiness grows greater as the impediment grows less, till the time is accomplished. The pain, however, does not diminish, but only the time of remaining in that pain. As far as their will is concerned, these souls cannot acknowledge the pain as such, so completely are they satisfied with the ordinance of God, so entirely is their will one with it in pure charity. On the other hand, they suffer a torment so extreme, that no tongue could describe it, no intellect could form the least idea of it, if God had not made it known by special grace ; which idea, however, God's grace has shown my soul ; but I cannot find words to express it with my tongue, yet the sight of it has never left my mind. I will describe

it as I can : they will understand it whose intellect the Lord shall vouchsafe to open.

DIVINE WISDOM MANIFESTED BY HELL AND PURGATORY

As the soul cleansed and purified finds no place wherein to rest but God, this being its end by creation, so the soul in a state of sin finds no place for it but hell, this being its end by the appointment of God. No sooner, then, does the soul leave the body in mortal sin than it goes straight to hell as to its allotted place, with no other guide than the nature of sin ; and should a soul not find itself thus prevented by the justice of God, but excluded altogether from His appointment, it would endure a still greater hell— for God's appointment partakes of His mercy, and is less severe than the sin deserves ; as it is, the soul, finding no place suited to it, nor any lesser pain provided for it by God, casts itself into hell as into its proper place. Thus, with regard to purgatory, when the soul leaves the body, and finds itself out of that state of purity in which it was created, seeing the hindrance, and that it can only be removed by purgatory, without a moment's hesitation it plunges therein : and were there no such means provided to remove the impediment, it would forthwith beget within itself a hell worse than purgatory, because by reason of this impediment it would see itself unable to reach God, its last end : and this hindrance would be so full of pain, that, in comparison with it, purgatory, though, as I have said, it be like hell, would not be worth a thought, but be even as nothing.

AGAIN I say that, on God's part, I see Paradise has no gate, but that whosoever will may enter therein ; for God is all mercy, and stands with open arms to

admit us to His glory. But still I see that the Being of
God is so pure (far more than one can imagine),
that should a soul see in itself even the least mote of
imperfection, it would rather cast itself into a thousand
hells than go with that spot into the presence of the
Divine Majesty. Therefore, seeing purgatory ordained
to take away such blemishes, it plunges therein, and
deems it a great mercy that it can thus remove them.

No tongue can express, no mind can understand,
how dreadful is purgatory. Its pain is like that of
hell ; and yet (as I have said) I see any soul with the
least stain of imperfection accept it as a mercy, not
thinking it of any moment when compared with being
kept from its Love. It appears to me that the greatest
pain the souls in purgatory endure proceeds from their
being sensible of something in themselves displeasing
to God, and that it has been done voluntarily against
so much goodness ; for, being in a state of grace,
they know the truth, and how grievous is any obstacle
which does not let them approach God.

THE LOVE OF GOD IN PURGATORY

ALL the things of which I have spoken, when compared
with that of which I am assured in my intelligence,
so far as I am able to comprehend it in this life, are
of such intensity, that, by the side of them, all things
seen, all things felt, all things imagined, all things just
and true, seem to me lies and things of naught. I am
confounded at my inability to find stronger words.
I see that God is in such perfect conformity with the
soul, that when He beholds it in the purity wherein
it was created by His Divine Majesty, He imparts
a certain attractive impulse of His burning love,
enough to annihilate it, though it be immortal ; and
in this way so transforms the soul into Himself, its
God, that it sees in itself nothing but God, who goes

on thus attracting and inflaming it, until He has brought it to that state of existence whence it came forth—that is, the spotless purity wherein it was created. And when the soul, by interior illumination, perceives that God is drawing it with such loving ardour to Himself, straightway there springs up within it a corresponding fire of love for its most sweet Lord and God, which causes it wholly to melt away : it sees in the Divine light how considerately, and with what unfailing providence, God is ever leading it to its full perfection, and that He does it all through pure love ; it finds itself stopped by sin, and unable to follow that heavenly attraction—I mean that look which God casts on it to bring it into union with Himself : and this sense of the grievousness of being kept from beholding the Divine light, coupled with that instinctive longing which would fain be without hindrance to follow the enticing look—these two things, I say, make up the pains of the souls in purgatory. Not that they think anything of their pains, however great they be ; they think far more of the opposition they are making to the will of God, which they see clearly is burning intensely with pure love to them. God meanwhile goes on drawing the soul to Himself by His looks of love mightily, and, as it were, with undivided energy : this the soul knows well ; and could it find another purgatory greater than this by which it could sooner remove so great an obstacle, it would immediately plunge therein, impelled by that conforming love which is between God and the soul.

ST. TERESA

1515–1582

TERESA was born of a noble family at Avila in Castile on March 28, 1515. She was a pious child and when she was only seven ran away from home with her little brother to seek martyrdom among the Moors. When she was sixteen she went as a boarder to the Augustinian convent at Avila, but ill-health sent her home. In 1533 she became a Carmelite at the Incarnation priory in the same town, and six years later recovered from a very serious sickness at the intercession of St. Joseph, for whom she had always a great devotion.

It was long before her fervour and perseverance were stabilized, and it was not till she was forty that she began to enter on the way of heroic sanctity. She was confirmed therein by St. Francis Borgia and St. Peter of Alcantara, and put herself under the direction of the Jesuit father Balthazar Alvarez.

The mitigated rule followed by all Carmelites at that time could not satisfy Teresa's aspirations, and in 1562 she founded, amid the greatest difficulties, the first monastery of reformed Carmelite nuns, St. Joseph's, at Avila. Here she wrote her autobiography and *The Way of Perfection*. In 1567 she founded the convent of Medina del Campo, and in the same year met for the first time St. John of the Cross, who was then less than half her own age. Together they soon established the first house of reformed friars of their order, at Duruelo.

Teresa spent the rest of her life setting up reformed convents up and down Spain, and it is difficult to know which is the more remarkable : the graces of prayer granted her by God (she experienced the 'spiritual marriage' in 1572), described by her in masterly fashion in the *Interior Castle*, or the tireless energy of her incredible activity

83

which she chronicles in the *Book of the Foundations*. On returning from one of these apostolic journeys she fell ill and died at Alba, on October 4, 1582. She was canonized in 1662.

St. Teresa was a most powerful personality, endowed with vivid imagination and piercing intelligence. She read a lot, especially the writings of Louis of Granada, St. Peter of Alcantara, St. John Cassian, St. Vincent Ferrer, and the *Spiritual Exercises* of St. Ignatius, and translated several works from Latin into Castilian. She is easily one of the greatest mystical writers who ever lived, and her books have helped countless souls on the road to perfection. Her writing is lively, vivid, and easily understood, and she describes the highest graces and physical phenomena of mysticism in a simple straight-forward way : the reader is captivated both by the books and by the writer.

TRANSLATIONS : *Life of St. Theresa of Jesus of the Order of our Lady of Carmel* (Thomas Baker, 1932).

The Way of Perfection (Thomas Baker, 1925).

The Interior Castle or The Mansions (Thomas Baker, 1930).

St. Teresa. By Henri Joly (Burns Oates & Washbourne, 1929).

A VISION OF HELL

SOME considerable time after our Lord had bestowed upon me the graces I have been describing, and others also of a higher nature, I was one day in prayer when I found myself in a moment, without knowing how, plunged apparently into hell. I understood that it was our Lord's will I should see the place which the devils kept in readiness for me, and which I had deserved by my sins. It was but a moment, but it seems to me impossible I should ever forget it, even if I were to live many years.

The entrance seemed to be by a long narrow pass, like a furnace, very low, dark, and close. The ground seemed to be saturated with water, mere mud,

exceedingly foul, sending forth pestilential odours, and covered with loathsome vermin. At the end was a hollow place in the wall, like a closet, and in that I saw myself confined. All this was even pleasant to behold in comparison with what I felt there. There is no exaggeration in what I am saying.

But as to what I then felt, I do not know where to begin, if I were to describe it ; it is utterly inexplicable. I felt a fire in my soul. I cannot see how it is possible to describe it. My bodily sufferings were unendurable. I have undergone most painful sufferings in this life, and, as the physicians say, the greatest that can be borne, such as the contraction of my sinews when I was paralysed, without speaking of others of different kinds, yea, even those of which I have also spoken, inflicted on me by Satan ; yet all these were as nothing in comparison with what I felt then, especially when I saw that there would be no intermission, nor any end to them.

These sufferings were nothing in comparison with the anguish of my soul, a sense of oppression, of stifling, and of pain so keen, accompanied by so hopeless and cruel an infliction, that I know not how to speak of it. If I said that the soul is continually being torn from the body it would be nothing—for that implies the destruction of life by the hands of another ; but here it is the soul itself that is tearing itself in pieces. I cannot describe that inward fire or that despair surpassing all torments and all pain. I did not see who it was that tormented me, but I felt myself on fire, and torn to pieces, as it seemed to me ; and, I repeat it, this inward fire and despair are the greatest torments of all.

Left in that pestilential place, and utterly without the power to hope for comfort, I could neither sit nor lie down : there was no room. I was placed as it were in a hole in the wall ; and those walls, terrible to look on of themselves, hemmed me in on every side.

I could not breathe. There was no light, but all was thick darkness. I do not understand how it is ; though there was no light, yet everything that can give pain by being seen was visible.

Our Lord at that time would not let me see more of hell. Afterwards I had another most fearful vision, in which I saw the punishment of certain sins. They were most horrible to look at ; but, because I felt none of the pain, my terror was not so great. In the former vision our Lord made me really feel I had been suffering them in the body there. I know now how it was, but I understood distinctly that it was a great mercy that our Lord would have me see with mine own eyes the very place from which His compassion saved me. I have listened to people speaking of these things, and I have at other times dwelt on the various torments of hell, though not often, because my soul made no progress by the way of fear ; and I have read of the diverse tortures, and how the devils tear the flesh with red-hot pincers. But all is as nothing before this ; it is a wholly different matter. In short, the one is a reality, the other a picture ; and all burning here in this life is as nothing in comparison with the fire that is there.

I was so terrified by that vision—and that terror is on me even now while I am writing—that though it took place nearly six years ago, the natural warmth of my body is chilled by fear even now when I think of it. And so, amid all the pain and suffering which I may have had to bear, I remember no time in which I do not think that all we have to suffer in this world is as nothing. It seems to me that we complain without reason. I repeat it, this vision was one of the grandest mercies of our Lord. It has been to me of the greatest service, because it has destroyed my fear of trouble and of the contradiction of the world, and because it has made me strong enough to bear up against them, and to give thanks to our Lord, who

has been my Deliverer, as it now seems to me, from such fearful and everlasting pains.

Ever since that time, as I was saying, everything seems endurable in comparison with one instant of suffering such as those I had then to bear in hell. I am filled with fear when I see that, after frequently reading books which describe in some manner the pains of hell, I was not afraid of them, nor made any account of them. Where was I? How could I possibly take any pleasure in those things which led me directly to so dreadful a place? Blessed for ever be Thou, O my God! and, oh, how manifest is it that Thou didst love me much more than I did love Thee! How often, O Lord, didst Thou save me from that fearful prison! And how I used to get back to it contrary to Thy will.

It was that vision that filled me with the very great distress which I feel at the sight of so many lost souls, especially of the Lutherans—for they were once members of the Church by baptism—and also gave me the most vehement desires for the salvation of souls; for certainly I believe that, to save even one from those overwhelming torments, I would most willingly endure many deaths. If here on earth we see one whom we specially love in great trouble or pain, our very nature seems to bid us compassionate him; and if those pains be great, we are troubled ourselves. What, then, must it be to see a soul in danger of pain, the most grievous of all pains, for ever? Who can endure it? It is a thought no heart can bear without great anguish. Here we know that pain ends with life at last, and that there are limits to it; yet the sight of it moves our compassion so greatly. That other pain has no ending; and I know not how we can be calm, when we see Satan carry so many souls daily away.

FIAT VOLUNTAS TUA

St. Teresa makes a fine commentary on the Our
Father in her *Way of Perfection*. Speaking of 'Thy
will be done on earth as it is is in heaven,' she says :

I wish to remind you what is the will of God, so
that you may know with whom you have to deal, as
the saying goes, and may realize what the good Jesus
is offering to the Father on your behalf. Know that
when you say ' Thy will be done' you are begging
that God's will may be carried out in you, for it is
this, and nothing else, for which you ask. You need
not fear that He will give you riches, or pleasures, or
great honours, or any earthly good—His love for you
is not so lukewarm—He places a higher value on your
gift and wishes to reward you generously, since He
has given you His kingdom even in this life. Would
you like to see how He treats those who make this
petition unreservedly ? Ask His glorious Son, who in
the garden uttered it truthfully and resolutely. See
whether the will of God was not accomplished in the
trials, the sufferings, the insults, and the persecutions
sent Him, until at last His life was ended on the cross.
Thus you see, daughters, what God gave to Him He
loved best : this shows what His will means. These
are His gifts in this world, and He grants them in
proportion to His affection for us. To souls He
cherishes most He gives more—and fewer to those
less dear to Him, according to their courage and the
love He sees they bear Him. For fervent love can
suffer much for Him, while tepidity will endure but
little. For my part, I believe that our love is the
measure of the cross we can bear ?

Then, sisters, if you have this love, think of what
you are doing : let not the promises you made to so
great a God be only words of empty compliment,
but force yourselves to suffer whatever God wishes.

Any other way of yielding Him our will is like offering someone a jewel, begging him to accept it, and holding it fast when he puts out his hand to take it. It is shameful to trifle thus with One who has done so much for us. Were there no other reason, it would be wrong to mock Him thus, again and again, whenever we repeat the *Pater Noster*. Let us give Him once for all the gem we have so often proffered Him— although He first gave us what we now tender to His Father.

ON NOT EXCUSING ONESELF USELESSLY

I AM overwhelmed with confusion at speaking on this subject, and I do not know how to fulfil my task. The fault is yours, sisters, for you bade me undertake the work—you must read it as best you can since I do my best to write it and you must not criticize its shortcomings. Such a book requires leisure ; as you know, I have so little that I have been unable to go on with it for a week, and I forget both what I have already written and how I intended to continue. I can do nothing but blame myself for my failings, and beg you not to imitate me by excusing yourselves as I am doing here. Not to exculpate ourselves when unjustly accused is a sublime virtue, and very edifying and meritorious ; but, although I have often taught it you, and by the mercy of God you practise it, yet His Majesty has never given me the grace to do so myself—may He grant that I do before I die ! Yet there always seems to me some good reason for thinking it would be better to make some excuse for myself. This is often lawful, indeed, sometimes it would be wrong to omit it, yet I have not sufficient discretion —or rather, humility—to know when it should be done. For indeed it requires great humility to see oneself blamed without cause, and to be silent ; we thus

imitate our Lord, who freed us from our sins. Be most careful to act in this way, sisters; it does us great good, while I can see no use in our exculpating ourselves, unless, as I said, when we might cause offence or scandal by not telling the truth. Anyone who is more prudent than I am will easily understand this. I think it is a great gain to accustom oneself to practise this virtue, and to endeavour to obtain from God the true humility that must be the result. Whoever is really humble ought to wish sincerely to be despised, persecuted, and condemned for serious offences without any just cause. If you seek to follow our Lord, in what better way can you do so? No bodily strength is needed here, nor the help of any one save God.

I wish these great virtues, my sisters, to be both our study and our penance. You know that I restrain you from other severe and excessive austerities, which if performed imprudently might injure your health. Here, however, there is nothing to fear; for, however great the interior virtues may be, they do not weaken the body so that it cannot keep the Rule of the religious life. These strengthen the soul, and, as I have often told you by constantly conquering yourselves in little things, you may train yourselves to gain the victory in great matters. But—how well I have written this, and how badly I practise it!—indeed, I have never been tried thus in any important affair, for I never heard any ill spoken of me that did not fall far short of the truth, if not in that particular matter, yet often enough in similar things: only too often in other ways have I offended our Lord God, and I thought people showed me a great kindness in not speaking of these. I always prefer that they should find fault with what I have not done, for the truth is very painful to hear; but for a false accusation, however grave, I care nothing, and in minor matters I follow my natural bent without thinking of what is most perfect. For this reason, I wish you to understand from the first,

and I desire each one of you to consider, how much is gained by this habit of not excusing yourselves. I think it can never do any harm, while its chief advantage is that we thus, to a certain degree, imitate our Lord. I say, ' to a certain degree,' for we are never wholly innocent when blamed, but are always guilty of many sins, for ' the just man falleth seven times a day,' and ' if we say we have no sin, the truth is not in us ' ; therefore, though we may not be guilty of this particular fault, yet we are never altogether free from offence as was the good Jesus.

O my Lord, when I remember in how many ways Thou didst suffer, who yet in no way didst deserve it, I know not what to say for myself, nor of what I am thinking when I shrink from suffering or defend myself from blame ! Thou knowest, O my only God ! that if there is aught that is right in me it comes from Thy hands. Why shouldst Thou not give me much instead of little ? If it is because I do not deserve it, neither have I deserved the graces Thou hast already bestowed on me. Can it be that I should wish men to think well of a thing so vile as I am, when they said such evil things of Thee, who art above every other good ? Do not permit this : forbid it, O my God ! Nor let me wish that anything displeasing to Thine eyes should be found in me, Thy handmaiden. See, O my Lord ! I am blind and I care but little for the light. Enlighten me and make me sincerely desire that all men should hate me, since I have so often abandoned Thee who lovest me so faithfully. Why do we act thus, O my God ? What joy do we think to find by pleasing creatures ? What does it matter of what guilt they accuse us if we are guiltless before Thee, O Lord ?

DELIGHTS OF PASSING LOVE

NOT long afterwards His Majesty began, according
to His promise, to make it clear that it was He Himself
who appeared, by the growth in me of the love of
God so strong, that I knew not who could have
infused it ; for it was most supernatural, and I had
not attained to it by any efforts of my own. I saw
myself dying with a desire to see God, and I knew
not how to seek that life otherwise than by dying.
Certain great impetuosities of love, though not so
intolerable as those of which I have spoken before,
nor yet of so great worth, overwhelmed me. I knew
not what to do ; for nothing gave me pleasure, and
I had no control over myself. Oh, supreme artifice
of our Lord ! How tenderly didst Thou deal with
Thy miserable slave ! Thou didst hide Thyself from
me, and didst yet constrain me with Thy love, with
a death so sweet, that my soul would never wish it over.

It is not possible for any one to understand these
impetuosities if he has not experienced them himself.
They are not an upheaving of the breast, nor those
devotional sensations, not uncommon, which seem on
the point of causing suffocation, and are beyond
control. That prayer is of a much lower order ;
and those agitations should be avoided by gently
endeavouring to be recollected ; and the soul should
be kept in quiet. . . .

These other impetuosities are very different. It
is not we who apply the fuel ; the fire is already
kindled, and we are thrown into it in a moment to be
consumed. It is by no efforts of the soul that it
sorrows over the wound which the absence of our
Lord has inflicted on it ; it is far otherwise ; for an
arrow is driven into the entrails to the very quick,
and into the heart at times, so that the soul knows
not what is the matter with it, not what it wishes for.

It understands clearly enough that it wishes for God, and that the arrow seems tempered with some herb which makes the soul hate itself for the love of our Lord, and willingly lose its life for Him. It is impossible to describe or explain the way in which God wounds the soul, or the very grievous pain inflicted, which deprives it of all self-consciousness ; yet this pain is so sweet, that there is no joy in the world which gives greater delight. And I have just said, the soul would wish to be always dying of this wound.

This pain and bliss together carried me out of myself, and I never could understand how it was. Oh, what a sight a wounded soul is !—a soul, I mean, so conscious of it as to be able to say of itself that it is wounded for so good a cause ; and seeing distinctly that it never did anything whereby this love should come to it, and that it does come from that exceeding love which our Lord bears it. A spark seems to have fallen suddenly upon it, that has set it all on fire. Oh, how often do I remember, when in this state, those words of David : ' *Quemadmodum desiderat cervus a fontes aquarun !* ' They seem to me to be literally true of myself.

When these impetuosities are not very violent they seem to admit of a little mitigation—at least, the soul seeks some relief, because it knows not what to do—through certain penances ; the painfulness of which, and even the shedding of its blood, are no more felt than if the body were dead. The soul seeks for ways and means to do something that may be felt, for the love of God ; but the first pain is so great, that no bodily torture I know of can take it away. As relief is not to be had here, these medicines are too mean for so high a disease. Some slight mitigation may be had, and the pain may pass away a little, by praying God to relieve its sufferings, but the soul sees no relief except in death, by which it thinks to attain completely to the fruition of its good.

PRAYER OF UNION :
THE MYSTICAL BUTTERFLY

You have heard how wonderfully silk is made—in a way such as God alone could plan—how it all comes from an egg resembling a tiny pepper-corn. Not having seen it myself, I only know of it by hearsay, so if the facts are inaccurate the fault will not be mine. When, in the warm weather, the mulberry trees come into leaf, the little egg which was lifeless before its food was ready, begins to live. The caterpillar nourishes itself upon the mulberry leaves until, when it has grown large, people place near it small twigs upon which, of its own accord, it spins silk from its tiny mouth until it has made a narrow little cocoon in which it buries itself. Then this large and ugly worm leaves the cocoon as a lovely little white butterfly.

If we had not seen this, but had only heard of it as an old legend, who could believe it ? Could we persuade ourselves that insects so utterly without the use of reason as a silkworm or a bee would work with such industry and skill in our service that the poor little silkworm loses its life over the task ? This would suffice for a short meditation, sisters, without my adding more, for you may learn from it the wonders and the wisdom of God. How if we knew the properties of all things ? It is most profitable to ponder over the grandeurs of creation and to exult in being the brides of such a wise and mighty King.

Let us return to our subject. The silkworm symbolizes the soul which begins to live when, kindled by the Holy Spirit, it commences using the ordinary aids given by God to all, and applies the remedies left by Him in His Church, such as regular confession, religious books, and sermons ; these are the cure for a soul dead in its negligence and sins and liable to

fall into temptation. Then it comes to life and continues nourishing itself on this food and on devout meditation until it has attained full vigour, which is the essential point, for I attach no importance to the rest. When the silkworm is full grown, as I told you in the first part of this chapter, it begins to spin silk and to build the house wherein it must die. By this house, when speaking of the soul, I mean Christ. I think I heard or read somewhere, either that our life is hid in Christ, or in God (which means the same thing), or that Christ is our life. It makes little difference to my meaning which of these quotations is correct. . . .

Forward then, my daughters ! Hasten over your work and build the little cocoon. Let us renounce self-love and self-will, care for nothing earthly, do penance, pray, mortify ourselves, be obedient, and perform all the other good works of which you know. Act up to your light ; you have been taught your duties. Die ! Die as the silkworm does when it has fulfilled the office of its creation, and you will see God and be immersed in His greatness, as the little silkworm is enveloped in its cocoon. Understand that when I say ' you will see God,' I mean in the manner described, in which He manifests Himself in this kind of union.

Now let us see what becomes of the ' silkworm,' for all I have been saying leads to this. As soon as by means of this prayer the soul has become entirely dead to the world, it comes forth like a lovely little white butterfly ! Oh, how great God is ! How beautiful is the soul after having been immersed in God's grandeur and united closely to Him for but a short time ! Indeed, I do not think it is ever so long as half an hour. Truly, the spirit does not recognize itself, being as different from what it was as is the white butterfly from the repulsive caterpillar. It does not know how it can have merited so great a good, or rather, whence this grace came which it well

knows it merits not. The soul desires to praise our Lord God and longs to sacrifice and die a thousand deaths for Him. It feels an unconquerable desire for great crosses and would like to perform the most severe penances ; it sighs for solitude and would have all men know God, while it is bitterly grieved at seeing them offend HIM. These matters will be described more fully in the next mansion ; there they are of the same nature, yet in a more advanced state the effects are stronger, because, as I told you, if, after the soul has received these favours, it strives to make still further progress, it will experience great things.

GOD'S CONTINUAL PRESENCE

WHEN our Lord is pleased to take pity on the sufferings, both past and present, endured through her longing for Him by this soul which He has spiritually taken for His bride, He, before consummating the celestial marriage, brings her into this His mansion or presence-chamber. This is the seventh mansion, for as He has a dwelling-place in heaven, so has He in the soul, where none but He may abide and which may be termed a second heaven. . . .

You must not think of the soul as insignificant and petty, but as an interior world containing the number of beautiful mansions you have seen ; as indeed it should, since in the centre of the soul there is a mansion reserved for God Himself.

When His Majesty deigns to bestow on the soul the grace of these Divine nuptials, He brings it into His presence-chamber and does not treat it as before. . . .

By some mysterious manifestation of the truth, the three Persons of the most Blessed Trinity reveal themselves, preceded by an illumination which shines on the spirit like a most dazzling cloud of light. The three Persons are distinct from one another ; a

sublime knowledge is infused into the soul, imbuing it with a certainty of the truth that the Three are of one substance, power, and knowledge, and are one God. Thus that which we hold as a doctrine of faith, the soul now, so to speak, understands by sight, though it beholds the blessed Trinity neither by the eyes of the body nor of the soul, this being no imaginary vision. All the Three Persons here communicate Themselves to the soul, speak to it and make it understand the words of our Lord in the Gospel that He and the Father and the Holy Ghost will come and make their abode with the soul which loves Him and keeps His commandments.

O my God, how different from merely hearing and believing these words is it to realize their truth in this way! Day by day a growing astonishment takes possession of this soul, for the Three Persons of the Blessed Trinity seem never to depart ; it sees with certainty, in the way I have described, that They dwell far within its own centre and depths ; though for want of learning it cannot describe how it is conscious of the indwelling of these Divine Companions.

You may fancy that such a person is beside herself and that her mind is too inebriated to care for anything else. On the contrary she is far more active than before in all that concerns God's service, and when at leisure she enjoys this blessed companionship. Unless she first deserts God I believe He will never cease to make her clearly sensible of His presence : she feels confident, as indeed she may, that He will never so fail her as to allow her to lose this favour after once bestowing it ; at the same time, she is more careful than before to avoid offending Him in any way.

This presence is not always so entirely realized, that is, so distinctly manifest, as at first, or as it is at times when God renews this favour, otherwise the recipient could not possibly attend to anything else nor live in society. Although not always seen by so

clear a light, yet whenever she reflects on it she feels the companionship of the Blessed Trinity. This is as if, when we were with other people in a very well lighted room, someone were to darken it by closing the shutters ; we should feel certain that the others were still there, though we were unable to see them.

You may ask : ' Could she not bring back the light and see them again ? ' This is not in her power ; when our Lord chooses, He will open the shutters of the understanding : He shows her great mercy in never quitting her and in making her realize it so clearly. His Divine Majesty seems to be preparing His bride for greater things by this Divine companionship which clearly helps perfection in every way and makes her lose the fear she sometimes felt when other graces were granted her.

A certain person so favoured found she had improved in all virtues whatever were her trials or labours, the centre of her soul seemed never moved from its resting-place. Thus in a manner her soul appeared divided : a short time after God had done for her this favour, while undergoing great sufferings, she complained of her soul as Martha did of Mary, reproaching it with enjoying solitary peace while leaving her so full of troubles and occupations that she could not keep it company.

ST. JOHN OF THE CROSS

1542-1591

JOHN's father, Gonzalez de Yepes, was a ruined nobleman who earned his living as a weaver at Fontiberos in Castile, and his boyhood was poor and arduous. He became an infirmarian at the hospital of Medina, and in the time he could spare from the sick attended classes at the Jesuit college. When he was twenty-one he became a Carmelite, taking the name of John of St. Mathias. After his novitiate he was sent to the university of Salamanca, where he studied for four years and acquired the knowledge of the Bible, the scholastic discipline, and the solid precise style which are displayed in his writings, and he read the German and Flemish mystics assiduously.

While still there, and thinking of seeking an austerer life among the Carthusians, he met St. Teresa, who fired him with her enthusiasm for the reform of the Carmelites. Together they founded the first house of reformed friars at Duruelo, and he changed his name to John of the Cross. A conflict then broke out between the two parties in the order, and John was imprisoned ; he escaped miraculously at the end of nine months, after undergoing scandalous ill-treatment. He was then prior at several places, but continued to suffer persecution. One day at Segovia he heard our Lord ask him, ' John, what reward do you look for from your labours ? ' ' Lord,' he replied, ' To suffer hardship and contempt for Your sake.'

St. John attained to the sublime state of 'spiritual marriage' and his union with God was complete and constant. St. Teresa said of him : ' One cannot talk about God with Father John, for he goes into ecstasy at once and makes others do the same.' He died at Ubeda in 1591, aged only forty-nine.

St. John is *the* mystical docto˙ of the Church, and from

the psychological side he is unrivalled. One of his great
achievements is to have made clear what he calls the
' dark night of the senses,' the way by which the soul
passes from meditation to infused contemplation ; he was
the first to distinguish and describe the great mystical
trials as the ' dark night of the senses ' and the ' dark
night of the soul.' In *The Ascent of Mount Carmel* he describes
how to reach the summit of perfection, and the necessary
perfect mortification of body and spirit is presented under
the figure of might. But this might is double : the active
might is the mortification which the soul imposes on
herself, and this is described in *The Ascent of Mount Carmel* ;
passive might is the far more intense purification with
which God visits the soul in various ways, and St. John
deals with this in *The Dark Night*. He distinguishes the
two purifications as the ' dark night of the senses,' which
leads to mystical contemplation, and the yet more terrible
' dark night of the soul,' which precedes the height of
union. In *The Spiritual Canticle* and *The Living Flame of
Love* he is concerned with the blessed condition of the soul
in the perfect union of love and the divinization of all her
faculties.

TRANSLATIONS : *The Complete Works of St. John of the Cross*
(Burns Oates & Washbourne, 1934).

The Burning Soul of St. John of the Cross. By Rodolphe
Hoornaert. Translated by Algar Thorold. (Burns Oates
& Washbourne, 1931).

Life of St. John of the Cross. By Father Bruno, O.C.D.
(London, 1932).

COMPLETE MORTIFICATION NECESSARY
FOR WISDOM

1. THE reason for which it is necessary for the soul,
in order to attain Divine union with God, to pass
through this dark night of mortification of the desires
and denial of pleasures in all things, is because all the
affections which it has for creatures are pure darkness
in the eyes of God, and, when the soul is clothed in

these affections, it has no capacity for being enlightened and possessed by the pure and simple light of God if it cast them not first from it ; for the light cannot agree with darkness ; since, as St. John says : *Tenebræ eam non comprehenderunt.* That is : The darkness could not receive the light.

2. The reason is that two contraries (even as philosophy teaches us) cannot coexist in one person ; and that darkness, which is affection for the creatures, and light, which is God, are contrary to each other, and have no likeness nor accord between one another, even as St. Paul explained to the Corinthians, saying : *Quæ conventio luci ad tenebras ?* That is to say : What communion can there be between light and darkness ? Hence it is that the light of Divine union cannot dwell in the soul if these affections first flee not away from it.

3. In order that we may the better prove what has been said, it must be known that the affection and attachment which the soul has for creatures renders the soul like to these creatures ; and the greater is its affection, the closer is the equality and likeness between them ; for love creates a likeness between that which loves and that which is loved. For which reason David, speaking of those who set their affections upon idols, said thus : *Similes illis fiant qui faciunt ea : et omnes qui confidunt in eis.* Which signifies : Let them that set their heart upon them be like to them. And thus he that loves a creature becomes as low as is that creature, and, in some ways, lower ; for love not only makes the lover equal to the object of his love, but even subjects him to it. Wherefore in the same way it comes to pass that the soul that loves anything else becomes incapable of pure union with God and transformation in Him. For the low estate of the creature is much less capable of union with the high estate of the Creator than is darkness with light. For all things of earth and heaven, compared with God, are nothing, as Jeremiah says in these words : *Aspexi*

terram, et ecce vacua erat, et nihil ; et coelos, et non erat lux in eis. I beheld the earth, he says, and it was void, and it was nothing ; and the heavens, and saw that they had no light. In saying that he beheld the earth void, he means that all its creatures were nothing, and that the earth was nothing likewise. And, in saying that he beheld the heavens and saw no light in them, he says that all the luminaries of heaven, compared with God, are pure darkness. So that in this sense, all the creatures are nothing ; and their affections, we may say, are less than nothing, since they are an impediment to transformation in God and the loss thereof, even as darkness is not only nothing, but less than nothing, since it is loss of light. And even as he that is in darkness comprehends not the light, so the soul that sets its affections upon creatures will be unable to comprehend God ; and, until it be purged, it will neither be able to possess Him here below, through pure transformation of love, nor yonder in clear vision. And, for greater clarity, we will now speak in greater detail.

4. All the being of creation, then, compared with the infinite being of God, is nothing. And therefore the soul that sets its affections upon the being of creation is likewise nothing in the eyes of God, and less than nothing ; for, as we have said, love makes equality and similitude, and even sets the lover below the object of his love. And therefore such a soul will in no wise be able to attain to union with the infinite being of God ; for that which is not can have no agreement with that which is. And, coming down in detail to certain examples, all the beauty of the creatures, compared with the infinite beauty of God, is the height of deformity, even as Solomon says in the Proverbs : *Fallax gratia, et vana est pulchritudo.* Favour is deceitful and beauty is vain. And thus the soul that is affectioned to the beauty of any creature is as the height of deformity in the eyes of God. And therefore

the soul that is deformed will be unable to become transformed in beauty, which is God, since deformity cannot attain to beauty; and all the grace and beauty of the creatures, compared with the grace of God, is the height of misery and of unattractiveness. Wherefore the soul that is ravished by the graces and beauties of the creatures has only supreme misery and unattractiveness in the eyes of God; and thus it cannot be capable of the infinite grace and loveliness of God; for that which has no grace is far removed from that which is infinitely gracious; and all the goodness of the creatures of the world, in comparison with the infinite goodness of God, may be described as wickedness. For there is naught good, save only God. And therefore the soul that sets its heart upon the good things of the world is supremely evil in the eyes of God. And, even as wickedness comprehends not goodness, even so much a soul cannot be united with God, who is supreme goodness. All the wisdom of the world and human ability, compared with the infinite wisdom of God, are pure and supreme ignorance, even as St. Paul writes *ad Corinthios*, saying: *Sapientia hujus mundi stultitia est apud Deum.* The wisdom of this world is foolishness in the eyes of God.

5. Wherefore any soul that makes account of all its knowledge and ability in order to come to union with the wisdom of God, is supremely ignorant in the eyes of God and will remain far removed from that wisdom; for ignorance knows not what wisdom is, even as St. Paul says that this wisdom seems foolishness to God.

6. Wherefore the soul that is enamoured of prelacy, or of any other such office, and longs for liberty of desire, is considered and treated, in the sight of God, not as a son, but as a base slave and captive, since it has not been willing to accept His holy doctrine, wherein He teaches us that he who would be greater must be less, and he who would be less must be greater.

And therefore such a soul will be unable to attain to
that true liberty of spirit which is encompassed in
His Divine union. For slavery can have no part with
liberty ; and liberty cannot dwell in a heart that
is subject to desires, for this is the heart of a slave ;
but it dwells in the free man, because he has the heart
of a son. It was for this reason that Sarah bade her
husband Abraham cast out the bond-woman and her
son, saying that the son of the bondwoman should not
be heir with the son of the free woman.

7. And all the delights and pleasures of the will in
all the things of the world, in comparison with all those
delights which are God, are supreme affliction, torment
and bitterness. And thus he that sets his heart upon
them is considered in the sight of God, as worthy of
supreme affliction, torment and bitterness ; and thus
he will be unable to attain to the delights of the
embrace of union with God, since he is worthy of
affliction and bitterness. All the wealth and glory
of all the creatures, in comparison with the wealth
which is God, is supreme poverty and wretchedness.
Thus the soul that loves and possesses creature wealth
is supremely poor and wretched in the sight of God,
and for this reason he will be unable to attain to that
wealth and glory which is the state of transformation
in God ; since that which is miserable and poor is
supremely far removed from that which is supremely
rich and glorious.

SPIRITUAL WISDOM

—*In order to arrive at having pleasure in everything,*
Desire to have pleasure in nothing.
—*In order to arrive at possessing everything,*
Desire to possess nothing.
—*In order to arrive at being everything,*
Desire to be nothing.

—In order to arrive at a knowledge of everything,
Desire to know nothing.
—In order to arrive at that wherein thou hast no pleasure,
Thou must go by a way wherein thou hast no pleasure.
—In order to arrive at that which thou knowest not,
Thou must go by a way that thou knowest not.
—In order to arrive at that which thou possessest not,
Thou must go by a way that thou possessest not.
—In order to arrive at that which thou art not,
Thou must go through that which thou art not.

HINDERING CONTEMPLATION

A FAVOURITE theme with St. John is the importance for those whom God has led to contemplation not to hinder it by the activity of their reasoning and imaginative powers.

6. Great, therefore, is the error of many spiritual persons who have practised approaching God by means of images and forms and meditations, as befits beginners. God would now lead them on to further spiritual blessings, which are interior and invisible, by taking from them the pleasure and sweetness of discursive meditation ; but they cannot, or dare not, or know not how to detach themselves from those palpable methods to which they have grown accustomed. They continually labour to retain them, desiring to proceed, as before, by the way of consideration and meditation upon forms, for they think that it must be so with them always. They labour greatly to this end and find little sweetness or none ; rather the aridity and weariness and disquiet of their souls are increased and grow, in proportion as they labour for that earlier sweetness. They cannot find this in that earlier manner, for the soul no longer enjoys that food of sense, as we have said ; it needs not this, but another food, which is more delicate, more interior and partaking less of the nature of sense ;

it consists not in labouring with the imagination, but in setting the soul at rest, and allowing it to remain in its quiet and repose, which is more spiritual. For, the farther the soul progresses in spirituality, the more it ceases from the operation of the faculties in particular acts, for it becomes more and more occupied in one act that is general and pure ; and thus the faculties that were journeying to a place whither the soul has arrived cease to work, even as the feet stop and cease to move when their journey is over. For if all were motion, one would never arrive, and if all were means, where or when would come the fruition of the end and goal ?

7. It is piteous, then, to see many a one who, though his soul would fain tarry in this peace and rest of interior quiet, where it is filled with the peace and refreshment of God, takes from it its tranquillity, and leads it away to the most exterior things, and would make it return and retrace the ground it has already traversed, to no purpose, and abandon the end and goal wherein it is already reposing for the means which led it to that repose, which are meditations. This comes not to pass without great reluctance and repugnance of the soul, which would fain be in that peace that it understands not, as in its proper place even as one who has arrived, with great labour, and is now resting, feels pain if they make him return to his labour. And, as such souls know not the mystery of this new experience, the idea comes to them that they are being idle and doing nothing ; and thus they allow not themselves to be quiet, but endeavour to meditate and reason. Hence they are filled with aridity and affliction, because they seek to find sweetness where it is no longer to be found ; we may even say of them that the more they strive the less they profit, for, the more they persist after this manner, the worse is the state wherein they find themselves, because their soul is drawn farther away from spiritual

peace ; and this is to leave the greater for the less, and to retrace the road already traversed, and to seek to do that which has been done.

8. To such as these the advice must be given to learn to abide attentively and wait lovingly upon God in that state of quiet, and to pay no heed either to imagination or to its working ; for here, as we say, the faculties are at rest, and are working, not actively, but passively, by receiving that which God works in them ; and, if they work at times, it is not with violence or with carefully elaborated meditation, but with sweetness of love, moved less by the ability of the soul itself than by God, as will be explained hereafter.

THE TWO MYSTICAL NIGHTS

1. THIS night, which, as we say, is contemplation, produces in spiritual persons two kinds of darkness or purgation, corresponding to the two parts of man's nature—namely, the sensual and the spiritual. And thus the one night or purgation will be sensual, wherein the soul is purged according to sense, which is subdued to the spirit ; and the other is a night or purgation which is spiritual ; wherein the soul is purged and stripped according to the spirit, and subdued and made ready for the union of love with God. The night of sense is common and comes to many ; these are the beginners ; and of this night we shall first speak. The night of the spirit is the portion to very few, and these are they that are already practised and proficient, of whom we shall treat hereafter.

2. The first purgation or night is bitter and terrible to sense, as we shall now show. The second bears no comparison with it, for it is horrible and awful to the spirit, as we shall show presently. Since the night of sense is first in order and comes first, we shall first of all say something about it briefly, since more is written

of it, as of a thing that is more common ; and we shall pass on to treat more fully of the spiritual night, since very little has been said of this, either in speech or in writing, and very little is known of it, even by experience.

THE NIGHT OF THE SENSES : WHAT IT IS

3. SINCE, then, the conduct of these beginners upon the way of God is ignoble, and has much to do with their love of self and their own inclinations, as has been explained above, God desires to lead them farther. He seeks to bring them out of that ignoble kind of love ·to a higher degree of love for Him, to free them from the ignoble exercises of sense and meditation (wherewith, as we have said, they go seeking God so unworthily and in so many ways that are befitting), and to lead them to a kind of spiritual exercise wherein they can commune with Him more abundantly and are freed more completely from imperfections. For they have now had practice for some time in the way of virtue and have persevered in meditation and prayer, whereby, through the sweetness and pleasure that they have found therein, they have lost their love of the things of the world and have gained some degree of spiritual strength in God ; this has enabled them to some extent to refrain from creature desires, so that for God's sake they are now able to suffer a light burden and a little aridity without turning back to a time which they found more pleasant. When they are going about these spiritual exercises with the greatest delight and pleasure, and when they believe that the sun of Divine favour is shining most brightly upon them, God turns all this light of theirs into darkness, and shuts against them the door and the source of the sweet spiritual water which they were tasting in God whensoever and for as long as they

desired. (For, as they were weak and tender, there was no door closed to them, as St. John says in the Apocalypse, iii, 8.) And thus He leaves them so completely in the dark that they know not whither to go with their sensible imagination and meditation ; for they cannot advance a step in meditation, as they were wont to do aforetime, their inward senses being submerged in this night, and left with such dryness that not only do they experience no pleasure and consolation in the spiritual things and good exercises wherein they were wont to find their delights and pleasures, but instead, on the contrary, they find insipidity and bitterness in the said things ; for, as I have said, God now sees that they have grown a little, and are becoming strong enough to lay aside their swaddling clothes and be taken from the gentle breast ; so He sets them down from His arms and teaches them to walk on their own feet ; which they feel to be very strange, for everything seems to be going wrong with them.

4. To recollected persons this commonly happens sooner after their beginnings than to others, inasmuch as they are freer from occasions of backsliding, and their desires turn more quickly from the things of the world, which is what is needful if they are to begin to enter this blessed night of sense. Ordinarily no great time passes after their beginnings before they begin to enter this night of sense ; and the great majority of them do in fact enter it, for they will generally be seen to fall into these aridities.

5. With regard to this way of purgation of the senses, since it is so common, we might here adduce a great number of quotations from Divine Scripture, where many passages relating to it are continually found, particularly in the Psalms and the Prophets. However, I do not wish to spend time upon this, for he that cannot see them there will find the common experience of them to be sufficient.

SIGNS OF THE NIGHT OF THE SENSES

1. But since these aridities might frequently proceed, not from the night and purgation of the sensual desires aforementioned, but from sins and imperfections, or from weakness and lukewarmness, or from some bad humour or indisposition of the body, I shall here set down certain signs by which it may be known if this aridity proceeds from the aforementioned purgation, or if it arises from any of the aforementioned sins. For the making of this distinction I find that there are three principal signs.

2. The first is whether, when a soul finds no pleasure or consolation in the things of God, it also fails to find it in any thing created ; for, as God sets the soul in this dark night to the end that He may quench and purge its sensual desire, He allows it not to find attraction or sweetness in anything whatsoever. Hence it may be laid down as very probable that this aridity and insipidity proceed not from recently committed sins or imperfections. For, if this were so, the soul would feel in its nature some inclination or desire to taste other things than those of God ; for, whenever the desire is allowed indulgence in any imperfection, it immediately feels inclined thereto, whether little or much, in proportion to the pleasure and the love that it had for it. Since, however, this lack of enjoyment in things above or below might proceed from some indisposition or melancholy humour, which oftentimes makes it impossible for the soul to take pleasure in anything, it becomes necessary to apply the second sign and condition.

3. The second sign whereby a man may believe himself to be experiencing the said purgation is that ordinarily the memory is centred upon God, with painful care and solicitude, thinking that it is not serving God, but is backsliding, because it finds itself

without sweetness in the things of God. And in such a case it is evident that this lack of sweetness and this aridity come not from weakness and lukewarmness ; for it is the nature of lukewarmness not to care greatly or to have any inward solicitude for the things of God. There is thus a great difference between aridity and lukewarmness, for lukewarmness consists in great weakness and remissness in will and in the spirit, without solicitude as to serving God ; whereas purgative aridity is ordinarily accompanied by solicitude, with care and grief, as I say, because the soul is not serving God.

4. The third sign whereby this purgation of sense may be recognized is that the soul can no longer meditate or reflect in its sense of the imagination, as it was wont, however much it may of itself endeavour to do so. For God now begins to communicate Himself to it, no longer through sense, as He did aforetime, by means of reflections which joined and sundered its knowledge, but by pure spirit, into which consecutive reflections enter not ; but He communicates Himself to it by an act of simple contemplation, to which neither the exterior nor the interior senses of the lower part of the soul can attain. From this time forward, therefore, imagination and fancy can find no support in any meditation, and can gain no foothold by means thereof.

THE NIGHT OF THE SOUL

THE following passages are extracted from St. John's long account of the terrible sufferings of this state.

In the first place, because the light and wisdom of this contemplation is most bright and pure, and the soul which it assails is dark and impure, it follows that the soul suffers great pain when it receives it in itself, just as, when the eyes are dimmed by humours,

and become impure and weak, they suffer pain through the assault of the bright light. And when the soul is indeed assailed by this Divine light, its pain, which results from its impurity, is immense ; because, when this pure light assails the soul, in order to expel its impurity, the soul feels itself to be so impure and miserable that it believes God to be against it, and thinks that it has set itself up against God. This causes it so much grief and pain (because it now believes that God has cast it away), that one of the greatest trials which Job felt when God sent him this experience, was as follows, when he said : Why hast Thou set me against Thee, so that I am grievous and burdensome to myself? For, by means of this pure light, the soul now sees it impurity clearly (although darkly), and knows clearly that it is unworthy of God or of any creature. And what gives it most pain is that it thinks that it will never be worthy and that its good things are all over for it. This is caused by the profound immersion of its spirit in the knowledge and realization of its evils and miseries ; for this Divine and dark light now reveals them all to the eye, that it may see clearly how in its own strength it can never have aught else. In this sense we may understand that passage from David, which says : For iniquity Thou hast corrected man and hast undone his soul : he consumes away as the spider.

THE NIGHT OF THE SOUL EXPLAINED BY A COMPARISON

THE dark and hidden contemplation in this state brings extraordinary sufferings and a complete stripping bare of the soul's imperfections ; when she is cleansed, the state becomes peaceful and happy. St. John explains this by a well-known comparison.

But there is another thing here which afflicts and

distresses the soul greatly, which is that, as this dark night has hindered its faculties and affections in this way, it is unable to raise its affection or its mind to God, neither can it pray to Him, thinking as Jeremias thought concerning himself, that God has set a cloud before it through which its prayer cannot pass. For it is this that is meant by that which is said in the passage referred to, namely : He hath shut and enclosed my ways with square stones. And if it sometimes prays it does so with such lack of strength and of sweetness that it thinks that God neither hears it nor pays heed to it, as this prophet likewise declares in the same passage, saying : When I cry and entreat, He hath cast out my prayer. In truth this is no time for the soul to speak with God ; it should rather put its mouth in the dust, as Jeremias says, so that perchance there may come to it some present hope, and it may endure its purgation with patience. It is God who is passively working here in the soul ; wherefore the soul can do nothing. Hence it can neither pray nor be present at the Divine offices and pay attention to them, much less can it attend to other things and affairs which are temporal. Not only so, but it has likewise such distractions and times of such profound forgetfulness of the memory, that frequent periods pass by without its knowing what it has been doing or thinking, or what it is that it is doing or is going to do, neither can it pay attention, although it desire to do so, to anything that occupies it.

DESIRE OF UNION

In *The Spiritual Canticle* St. John expounds one of his poems stanza by stanza. Here is the explanation of the sixth stanza wherein the loving soul longs ardently for union.

1. For the greater clearness of what has been said,

and of what has still to be said, it is well to observe
at this point that this purgative and loving knowledge
or Divine light whereof we here speak acts upon the
soul which is purged and prepared for perfect union
with it in the same way as fire acts upon a log of wood
in order to transform it into itself; for material fire,
acting upon wood, first of all begins to dry it, by driving
out its moisture and causing it to shed the water which
it contains within itself. Then it begins to make it
black, dark, and unsightly, and even to give forth
a bad odour, and, as it dries it little by little, it brings
out and drives away all the dark and unsightly
accidents which are contrary to the nature of fire.
And, finally, it begins to kindle it externally and give
it heat, and at last transforms it into itself and makes
it as beautiful as fire. In this respect, the wood has
neither passivity nor activity of its own, save for its
weight, which is greater, and its substance, which
is denser than that of fire, for it has in itself the
properties and actions of fire. Thus it is dry and it
dries ; it is hot and heats ; it is bright and gives
brightness ; and it is much less heavy than before.
All these properties and effects are caused in it by
the fire.

2. In this same way we have to philosophize with
respect to this Divine fire of contemplative love,
which, before it unites and transforms the soul in
itself, first purges it of all its contrary accidents. It
drives out its unsightliness, and makes it black and
dark, so that it seems worse than before and more
unsightly and abominable than it was wont to be.
For this Divine purgation is removing all the evil
and vicious humours which the soul has never per-
ceived because they have been so deeply rooted and
grounded in it ; it has never realized, in fact, that it
has had so much evil within itself. But now that they
are to be driven forth and annihilated, these humours
reveal themselves, and become visible to the soul

because it is so brightly illumined by this dark light
of Divine contemplation (although it is no worse than
before, either in itself or in relation to God) ; and,
as it sees in itself that which it saw not before, it is
clear to it that it is not only unfit for God to see it,
but that it deserves His abhorrence and that He does
indeed abhor it.

GOD HIDDEN IN THE SOUL

5. But, besides all this, speaking now somewhat accord-
ing to the sense and the affection of contemplation, in
the vivid contemplation and knowledge of the creatures,
the soul sees with great clearness that there is in them
such abundance of graces and virtues and beauty
wherewith God endowed them, that, as it seems to
her, they are all clothed with marvellous natural
beauty, derived from and communicated by that
infinite supernatural beauty of the image of God,
whose beholding of them clothes the world and all
the heavens with beauty and joy ; just as does also the
opening of His hand, whereby, as David says : *Imples
omne animal benedictione.* That is to say : Thou fillest
every animal with blessing. And therefore the soul,
being wounded in love by this trace of the beauty of
her Beloved which she has known in the creatures,
yearns to behold that invisible beauty, and speaks as
in the stanza following.

Stanza VI

*Ah, who will be able to heal me ! Surrender thou thyself now
 completely.*
*From to-day do thou send me now no other messenger. For
 they cannot tell me what I wish.*

EXPOSITION

1. As the creatures have given the soul signs of her
Beloved, by revealing to her in themselves traces of

His beauty and excellence, her love has increased, and in consequence the pain which she feels at His absence has grown (for the more the soul knows of God, the more grows her desire to see Him) ; and when she sees that there is naught that can cure her pain save the sight and the presence of her Beloved, she mistrusts any other remedy, and in this stanza begs Him for the surrender and possession of His presence, entreating Him from that day forth to entertain her with no other knowledge and communications from Himself, since these satisfy not her desire and will, which is contented with naught less than the sight and presence of Him. Wherefore, she says, let Him be pleased to surrender Himself in truth, in complete and perfect love, and thus she says :

Ah, who will be able to heal me !

2. As though she had said : Among all the delights of the world and the satisfaction of the senses, and the pleasures and sweetness of the Spirit, naught of a truth will be able to heal me, naught will be able to satisfy me. And since this is so :

Surrender thou thyself now completely.

3. Here it is to be noted that any soul that truly loves cannot wish to gain satisfaction and contentment until it truly possess God. For not only do all other things fail to satisfy it, but rather, as we have said, they increase its hunger and desire to see Him as He is. And thus, since each visit that the soul receives from the Beloved, whether it be of knowledge, or feeling, or any other communication soever (which are like messengers that communicate to the soul some knowledge of who He is, increasing and awakening the desire the more, even as crumbs increase a great hunger), makes it grieve at being entertained with so little, the soul says : 'Surrender thou thyself completely.'

4. Since all that can be known of God in this life, much though it be, is not true knowledge for it is knowledge in part and very far off, while to know Him essentially is true knowledge, which the soul begs here, therefore she is not content with these other communications, and says next :

From to-day do thou send me now no other messenger.

5. As though she were to say : Permit me not henceforward to know Thee thus imperfectly through these messengers—to wit, by the knowledge and the feelings that I am given of Thee, so far distant and removed from that which my soul desires of Thee. For to one who grieves for Thy presence, well knowest Thou, my Spouse, that the messengers bring an increase of affliction : for the one reason, because with the knowledge of Thee that they give they re-open the wound ; for the other, because they seem but to delay Thy coming. Wherefore from this day forth do Thou send me no more of such far distant knowledge, for if until now I could make shift with them, since I neither knew Thee nor loved Thee much, now the greatness of the love that I have to Thee cannot be satisfied with this earnest of knowledge : wherefore do Thou surrender Thyself completely. It is as if she said more clearly : This thing, O Lord my Spouse, that Thou art giving of Thyself in part to my soul, do Thou now give completely and wholly. And this thing that Thou art showing as in glimpses, do Thou now show completely and clearly. This that Thou art communicating through intermediaries, which is like to communicating Thyself in mockery, do Thou now communicate completely and truly, giving Thyself through Thyself. For at times in Thy visits it seems that Thou art about to give the jewel of the possession of Thyself, and, when my soul regards it well, she finds herself without it ; for Thou hidest it from her, which is as it were to give it in mockery. Surrender

Thyself, then, completely, giving Thyself wholly to the whole of my soul, that it wholly may have Thee wholly, and be Thou pleased to send me no other messenger.

For they cannot tell me what I wish.

6. As though she were to say : I wish for Thee wholly, and they are unable and know not how to speak to me of Thee wholly ; for naught on earth or in heaven can give the soul the knowledge which she desires to have of Thee, and thus they cannot tell me that which I wish. In place of these messages, therefore, be Thou Thyself messenger and messages both.

THE SHAFT OF LOVE

HE speaks of such an extraordinary grace as that enjoyed by St. Teresa, who was as it were pierced with a lance from the hand of a seraph.

No mortal man can know if he be worthy of the grace or of the abomination of God. So that the intent of the soul in this present line is not only to beg for sensible and affective devotion, wherein there is neither certainty nor evidence of the possession of the Spouse in this life by grace, but also to beg for the presence and clear vision of His Essence, wherewith it desires to be given assurance and satisfaction in glory.

3. This same thing was signified by the Bride in the Divine Songs when, desiring union and fellowship with the divinity of the Word her Spouse, she begged the Father for it, saying : *Indica mihi, ubi pascas, ubi cubes in meridie.* Which is to say : Tell me where Thou feedest, and where Thou dost rest at noon. For to enquire of Him where He fed was to beg that she might be shown the Essence of the Divine Word, for the Father glories not, save in the Word, His only Son, neither feeds upon aught else. And to beg Him

to show her where He rested at noon was to beg that self-same thing, since the Father rests not, neither is present in any place, save in His Son, in whom He rests, communicating to Him all His Essence—'at noon,' which is in Eternity, where He ever begets Him. It is this pasture, then, where the Father feeds, and this flowery bed of the Divine Word, where He rests hidden from every mortal creature, that the Bride—the soul—entreats when she says : 'Whither hast Thou hidden Thyself?'

4. And it is to be observed, if one would learn how to find this Spouse (so far as may be in this life), that the Word, together with the Father and the Holy Spirit, is hidden essentially in the inmost centre of the soul. Wherefore the soul that would find Him through union of love must issue forth and hide itself from all created things according to the will, and enter within itself in deepest recollection, communing there with God in loving and affectionate fellowship, esteeming all that is in the world as though it were not. Hence St. Augustine, speaking with God in the *Soliloquies*, said : I found Thee not, O Lord, without, because I erred in seeking Thee without that wert within.' He is, then, hidden within the soul, and there the good contemplative must seek Him, saying : 'Whither hast Thou hidden Thyself?'

And hast left me, Beloved, to my sighing?

5. The Bride calls Him ' Beloved,' in order the more to move and incline Him to her prayer, for, when God is loved indeed, He hears the prayers of His lover with great readiness ; and then in truth He can be called Beloved when the soul is wholly with Him and has not its heart set on aught that is outside Him. Some call the Spouse ' Beloved ' when He is not in truth their Beloved, because they have not their heart wholly with Him ; and thus, before the Spouse, their petition is of less effect.

6. And in the words which she then says : ' And
hast left me to my sighing,' it is to be observed that the
absence of the Beloved is a continual sighing in the
heart of the lover, because apart from Him she loves
naught, rests in naught and finds relief in naught ;
whence a man will know by this if he have indeed
love toward God—namely, if he be content with aught
that is less than God. To this sighing St. Paul referred
clearly when he said : *Nos intra nos gemimus, expectantes
adoptionem filiorum Dei.* That is : We groan within
ourselves, waiting for the adoption and possession
of sons of God. Which is as though he said : Within
our heart, where we have the pledge, we feel that
which afflicts us—to wit, the absence. This, then, is
the sighing which the soul ever makes, for sorrow at
the absence of her Beloved, above all when, having
enjoyed some kind of sweet and delectable communion
with Him, she is left dry and alone.

THE DART OF LOVE

WE know that the heart of St. Teresa was pierced by the
dart of a seraph. It is a grace of this kind which the
mystical Doctor describes in the *Living Flame of Love.*

But there is another and more sublime way
wherein the soul may be cauterized, which is after
this manner. It will come to pass that, when the
soul is enkindled in this love, although not so perfectly
as in the way of which we have spoken (though it is
most meet that it should be so with a view to that
which I am about to describe), the soul will be
conscious of an assault upon it made by a seraph
armed with a dart of most enkindled love, which will
pierce the soul, as it were an enkindled coal, or, to
speak more truly, as a flame, and will cauterize it in a
most sublime manner ; and, when it has pierced and
cauterized it thus, the flame will rush forth and will

rise suddenly and vehemently, even as comes to pass in a furnace or a forge highly heated ; when they stir and poke the fire, the flame becomes hotter and the fire revives, and then the soul is conscious of this wound, with a delight which transcends all description ; for besides being wholly moved by the stirring and the impetuous motion given to its fire, wherein the heat and melting of love is great, the keen wound and the healing herb wherewith the effect of the dart was being greatly assuaged are felt by the soul in the substance of the spirit, even as in the heart of him whose soul has been thus pierced.

Who can speak fittingly of this grain of mustard seed which now seems to remain in the centre of the heart of the spirit, and which is the point of the wound and the delicacy of its delight? And the soul feels its love to be increasing and to be growing in strength and refinement to such a degree that it seems to have within it seas of fire which reach to the farthest heights and depths, filling it wholly with love.

Few souls attain to this state, but some have done so, especially those whose virtue and spirituality was to be transmitted to the succession of their children. For God bestows spiritual wealth and strength upon the head of a house according as He means his descendants to inherit the first-fruits of the Spirit.

THE SOUL DYING OF LOVE

THEREFORE it must be known, with regard to the natural dying of souls that reach this state, that, though the manner of their death, from the natural standpoint, is similar to that of others, yet, in the cause and mode of their death there is a great difference. For while the deaths of others may be caused by infirmities or length of days, when these souls die, although it may be from some infirmity, or from old

age, their spirits are wrested away by nothing less than some loving impulse and encounter far loftier and of greater power and strength than any in the past, for it has succeeded in breaking the web and bearing away a jewel, which is the spirit. And thus the death of such souls is very sweet and gentle, more so than was their spiritual life all their life long, for they die amid the delectable encounters and sublimest impulses of love, being like to the swan, which sings most gently when it is at the point of death. For this reason David said that the death of saints in the fear of God was precious.

ST. FRANCIS DE SALES

1567–1622

FRANCIS DE SALES belonged to a noble Savoyard family, and was born at Thourens in 1567. He went to school at Annecy and then studied for seven years at the Jesuit college in Paris, where at his own wish he included a course in theology. While there he was tempted to despair by the idea of predestination, but recovered equilibrium before an image of our Lady ' of Deliverance.' When he was twenty-one he went to read law at the university of Padua, but on returning home announced his wish to become a priest. His father opposed the idea, for he had planned a ' good marriage ' for his son, but upon the Bishop of Geneva promising a distinguished benefice, Francis was allowed to be ordained.

In 1594 he went into the Chablais, where Calvinism was rampant, and reclaimed large numbers for the Faith by his energy, knowledge, and, above all, kindness ; he held conferences with the formidable Bèza himself and even had hopes of his conversion. In 1599 he was appointed coadjutor to the Bishop of Geneva, and three years later succeeded him in the see. He was a model bishop, discharging his pastoral office without intermission and yet finding time to write. With St. Jane Frances de Chantal, he in 1610 founded the Visitation nuns, primarily for widows and others who are not strong enough to manage the more austere rules.

The influence of St. Francis was far-reaching. He was invited to preach in many dioceses, and often visited Paris, where he was friendly with St. Vincent de Paul, Cardinal de Bérulle, and other holy men of that time, and preached almost daily to crowded congregations. He died at Lyons in 1622, was canonized in 1665, and was

proclaimed a doctor of the Church by Pope Pius IX in 1877.

St. Francis de Sales holds a very high place among spiritual writers, his principal works being the *Introduction to the Devout Life* and the *Treatise on the Love of God*. The first, a justly famous book, carries the reader into the realm of infused contemplation, and both had a huge success. He had a gift for presenting spiritual matters clearly and attractively, making plain the most abstruse ideas and allowing his own loveable character to inform all he wrote

TRANSLATIONS : *L'Introduction à la vie dévote. Le traité de l'Amour de Dieu. Sermons. Lettres. Entretiens Spirituels. Introduction to the Devout Life.*

Treatise on the Love of God.

Letters to Persons in Religion. With an introduction by Bishop Hedley.

The Spiritual Conferences. Edited under the supervision of Cardinal Gasquet and Dom Benedict Mackey.

The Spirit of St. Francis de Sales. By J. P. le Camus.

St. Francis de Sales. By A. D. Margerie. All published by Burns Oates & Washbourne.

THE RECOLLECTED SOUL

THE PRAYER OF QUIET

THE soul, then, being thus inwardly recollected in God or before God, now and then becomes so sweetly attentive to the goodness of her well-beloved, that her attention seems not to her to be attention, so purely and delicately is it exercised ; as it happens to certain rivers, which glide so calmly and smoothly that beholders and such as float upon them, seem neither to see nor feel any motion, because the waters are not seen to ripple or flow at all. And it is this admirable repose of the soul which the blessed virgin St. Teresa of Jesus names prayer of quiet, not far different from that which she also calls the sleep of the powers, at least if I understand her right.

Even human lovers are content, sometimes, with being near or within sight of the person they love without speaking to her, and without even distinctly thinking of her or her perfections, satiated, as it were, and satisfied to relish this dear presence, not by any reflection they make upon it, but by a certain gratification and repose, which their spirit takes in it. *A bundle of myrrh is my beloved to me, he shall abide between my breasts. My beloved to me, and I to him, who feedeth among the lilies, till the day break, and the shadows retire. Shew me, O thou whom my soul loveth, where thou feedest, where thou liest in the mid-day.* Do you see, Theomitus, how the holy Sulamitess is contented with knowing that her well-beloved is with her, whether in her bosom, or in her gardens, or elsewhere, so she know where He is. And indeed she is the Sulamitess, wholly peaceable, calm and at rest.

Now this repose sometimes goes so deep in its tranquillity, that the whole soul and all its powers fall as it were asleep, and make no movement nor action whatever except the will alone, and even this does no more than receive the delight and satisfaction which the presence of the well-beloved affords. And what is yet more admirable is, that the will does not even perceive the delight and contentment which she receives, enjoying it insensibly, being not mindful of herself, but of Him whose presence gives her this pleasure, as happens frequently when, surprised by a light slumber, we only hear indistinctly what our friends are saying around us, or feel their caresses almost imperceptibly, not feeling that we feel.

However, the soul who in this sweet repose enjoys this delicate sense of the Divine presence, though she is not conscious of the enjoyment, yet clearly shows how dear and precious this happiness. is unto her, if one offer to deprive her of it or divert her from it ; for then the poor soul complains, cries out, yea sometimes weeps, as a little child awakened before it has

taken its full sleep, who, by the sorrow it feels in being
awakened, clearly shows the content it had in sleeping.
Hereupon the heavenly shepherd adjures the daughters
of Jerusalem, *by the roes and harts of the fields, not to
make the beloved awake until she pleases,* that is, to let
her awake of herself. No, Theotimus, a soul thus
recollected in her God would not change her repose
for the greatest goods in the world.

Such, or little different from it, was the quiet of
most holy Magdalen, when sitting at her Master's
feet she heard His holy word. Behold her, I beseech
you, Theotimus, she is in a profound tranquillity,
she says not a word, she weeps not, she sobs not, she
sighs not, she stirs not, she prays not. Martha, full of
business, passes and repasses through the hall : Mary
notices her not. And what does this mean—she
hearkens ? It means that she is there as a vessel of
honour, to receive drop by drop the myrrh of sweetness
which the lips of her well-beloved distilled into her
heart ; and this Divine lover, jealous of this love-sleep
and repose of this well-beloved, chid Martha for
wanting to awaken her ; *Martha, Martha, thou are
careful, and art troubled about many things. But one thing
is necessary, Mary hath chosen the best part, which shall not
be taken away from her.* But what was Mary's portion
or part ? To remain in peace, repose, and quiet,
near unto her sweet Jesus.

The well-beloved St. John is ordinarily painted,
in the Last Supper, not only lying, but even sleeping
in his Majesty's bosom, because he was seated after
the fashion of the Easterns (*Levantins*), so that his head
was towards his dear lover's breast ; and as he slept
no corporal sleep there—what likelihood of that ?—so
I make no question but that, finding himself so near
the breasts of the eternal sweetness, he took a profound
mystical sleep, like a child of love which locked to its
mother's breasts sucks while sleeping. Oh ! what a
delight it was to this Benjamin, child of his Saviour's

joy, to sleep in the arms of that father, who the day after, recommended him, as the Benoni, child of pain, to his mother's sweet breasts. Nothing is more desirable to the little child, whether he wake or sleep, than his father's bosom and mother's breast.

Wherefore, when you shall find yourself in this simple and pure filial confidence with our Lord, stay there, my dear Theotimus, without moving yourself to make sensible acts, either of the understanding or of the will ; for this simple love of confidence, and this love-sleep of your spirit in the arms of the Saviour, contains by excellence all that you go seeking hither and thither to satisfy your taste ; it is better to sleep upon this sacred breast than to watch elsewhere, wherever it be.

THE WOUND OF LOVE

Love is the first, yea the principle and origin, of all the passions, and therefore it is love that first enters the heart ; and because it penetrates and pierces down to the very bottom of the will where its seat is, we say it wounds the heart. ' It is sharp,' says the Apostle of France, ' and enters into the spirit most deeply.' The other affections enter indeed, but by the agency of love, for it is this which piercing the heart makes a passage for them. It is only the point of the dart that wounds, the rest only increases the wound and the pain.

Now, if it wound, it consequently gives pain. Pomegranates, by their vermilion colour, by the multitude of their seeds, so close set and ranked, and by their fair crowns, vividly represent, as St. Gregory says, most holy charity, all red by reason of its ardour towards God, loaded with all the variety of virtues, and alone bearing away the crown of eternal reward : but the juice of pomegranates, which, as

we know is so agreeable both to the healthy and to the sick, is so mingled of sweet and sour that one can hardly discern whether it delights the taste more because it has a sweet tartness or because it has a tart sweetness. Verily, Theotimus, love is thus bitter-sweet, and while we live in this world it never has the sweetness perfectly sweet, because it is not perfect, nor ever purely satiated and satisfied ; and yet it fails not to be of very agreeable taste, its tartness correcting the lusciousness of its sweetness, as its sweetness heightens the relish of its tartness. But how can this be ? You shall see a young man enter into a company, free, hearty, and in the best of spirits, who, being off his guard, feels, before he goes away, that love, making use of the glances, the gestures, the words, yea even of the hair of a silly and weak creature, as of so many darts, has smitten and wounded his poor heart, so that there he is, all sad, gloomy and depressed. Why I pray you is he sad ? Without doubt because he is wounded. And what has wounded ? Love. But love being the child of complacency, how can it wound and give pain ? Sometimes the beloved object is absent, and then, my dear Theotimus, love wounds the heart by the desire which it excites ; this it is which, being unable to satiate itself, grievously torments the spirit.

If a bee had stung a child, it were to poor purpose, to say to him : Ah ! my child, the bee that stung you is the very same that makes the honey you are so fond of. For he might say : It is true, that its honey is very pleasant to my taste, but its sting is very painful, and while its sting remains in my cheek I cannot be at peace, and do you not see that my face is all swollen with it ? Theotimus, love is indeed a complacency, and consequently very delightful, provided that it does not leave in our heart the sting of desire ; for when it leaves this, it leaves therewith a great pain. True it is this pain proceeds from love, and therefore

it is a loveable and beloved pain. Hear the painful yet love-full ejaculations of a royal lover. *My soul hath thirsted after the strong living God ; when shall I come and appear before the face of God ? My tears have been my bread day and night, whilst it is said to me daily : Where is thy God ?* And the sacred Sulamitess wholly steeped in her dolorous loves, speaking to the daughters of Jerusalem : *Ah !* says she, *I adjure you, O daughters of Jerusalem, if you find my beloved, that you tell him that I languish with love. Hope that is deferred afflicteth the soul.*

Now the painful wounds of love are of many sorts. (1) The first strokes we receive from love are called wounds because the heart which appeared sound, entire and all its own before its love, being struck with love begins to separate and divide itself from itself, to give itself to the beloved object. Now this separation cannot be made without pain, seeing that pain is nothing but the division of living things which belong to one another. (2) Desire incessantly stings and wounds the heart in which it is, as we have said. (3) But, Theotimus, speaking of heavenly love, there is in the practice of it a kind of wound given by God Himself to the soul which He would highly perfect. For He gives her admirable sentiments of and incomparable attractions for His sovereign Goodness, as if pressing and soliciting her to love Him ; and then she forcibly lifts herself up as if to soar higher towards her Divine object ; but stopping short, because she cannot love as much as she desires ; O God ! She feels a pain which has no equal. At the same time that she is powerfully drawn to fly towards her dear well-beloved, she is also powerfully kept back and cannot fly, being chained to the base miseries of this mortal life and of her own powerlessness : she desires *the wings of a dove that she might fly away and be at rest,* and she finds not. There then she is, rudely tormented between the violence of her desires and her own powerlessness. *Unhappy man that*

I am, said one of those who have experienced this torture, *who shall deliver me from the body of this death?* In this case, if you notice, Theotimus, it is not the desire of a thing absent that wounds the heart, for the soul feels that her God is present ; He has already led her into His wine-cellar, He has planted upon her heart the banner of love ; but still, though already He sees her wholly His, He urges her, and from time to time casts a thousand thousand darts of His love, showing her, in new ways, how much more He is loveable than loved. And she, who has not so much force to love as love to force herself, seeing her forces so weak in respect of the desire she has to love worthily Him whom no force of love can love enough—Ah ! she feels herself tortured with an incomparable pain ; for, as many efforts as she makes to fly higher in her desire in love, so many thrills of pain does she receive.

This heart in love with its God, desiring infinitely to love, sees notwithstanding that it can neither love nor desire sufficiently. And this desire which cannot come to effect is as a dart in the side of a noble spirit ; yet the pain which proceeds from it is welcome, because whosoever desires earnestly to love, loves also earnestly to desire, and would esteem himself the most miserable man in the universe, if he did not continue the desire to love that which is so sovereignly worthy of love. Desiring to love, he receives pain ; but loving to desire, he receives sweetness.

My God ! Theotimus, what am I going to say ? The blessed in heaven, seeing that God is still more loveable than they are loving, would fail and eternally perish with a desire to love Him still more if the most holy will of God did not impose upon theirs the admirable repose which it enjoys : for they so sovereignly love this sovereign will, that its willingness stays theirs, and the Divine contentment contents them, they acquiescing to be limited in their love even by that will whose goodness is the object of love.

If this were not so, their love would be equally delicious and dolorous, delicious by the possession of so great a good, dolorous through an extreme desire of a greater love. God therefore continually drawing arrows, if we may say so, out of the quiver of His infinite beauty, wounds the heart of His lovers, making them clearly see that they do not love Him nearly as much as He is worthy to be loved. That mortal who does not desire to love the Divine goodness more, loves Him not enough ; sufficiency in this Divine exercise is not sufficient, when a man would stay in it as though it sufficed him.

ABANDONMENT TO GOD'S PLEASURE

WE may well believe that the most sacred Virgin, our Lady, received so much pleasure in carrying her little Jesus in her arms, that delight beguiled weariness, or at least made it agreeable ; for if a branch of *agnus castus* can solace and unweary travellers, what solace did not the glorious mother receive in carrying the immaculate Lamb of God ? And though she permitted Him now and then to run on foot by her, she holding Him by the hand, yet this was not because she would not rather have had Him hanging about her neck and on her breast, but it was to teach Him to form His steps and walk alone. And we ourselves, Theotimus, as little children of the heavenly Father, may walk with Him in two ways. For we may, in the first place, walk with the steps of our own will which we conform to His, holding always with the hand of our obedience the hand of His Divine intention, and following it wheresoever it leads—which is what God requires from us by the significance of His will ; for since He wills me to do what He ordains, He wills me to have the will to do it : God has signified that He wills me to keep holy the day of rest ; since He wills me to do

it, He wills then that I will do it, and for this end
I should have a will of my own, by which I follow
His, conforming myself and corresponding to His.
But we may on other occasions walk with our Saviour
without any will of our own, letting ourselves simply
be carried at His Divine good pleasure, as a little
child in its mother's arms, by a certain kind of consent
which may be termed union or rather unity of our heart
with God's ; and this is the way that we are to en-
deavour to comport ourselves in God's will of good-
pleasure, since the effects of this will of good-pleasure
proceed purely from His Providence, and we do not
effect them, but they happen to us. True it is we may
will them to come according to God's will, and this
willing is excellent, yet we may also receive the events
of heaven's good-pleasure by a most simple tranquillity
of our will, which, willing nothing whatever, simply
acquiesces in all that God would have done in us,
on us, or by us.

If one had asked the sweet Jesus when He was
carried in His mother's arms, whither He was going,
might He not with good reason have answered : I go
not, 'tis My mother that goes for Me : And if one
had said to Him : But at least do you not go with
your mother ? Might He not reasonably have replied :
No, I do not go, or if I go whither My mother carries
Me, I do not Myself walk with her nor by My own
steps, but by My mother's, by her, and in her. But
if one had persisted with Him, saying : But at least,
O most dear Divine Child, You really will to let
Yourself be carried by Your sweet mother ? No,
verily, might He have said, I will nothing of all this,
but as My entirely good mother walks for Me so she
wills for Me ; I leave her the care as well to go as
to will to go for Me where she likes best ; and as I
go not, but by her steps so I will not, but by her will ;
and from the instant I find Myself in her arms, I give
no attention either to willing or not willing, turning

all other cares over to My mother, save only the care
to be on her bosom, to suck her sacred breast, and to
keep Myself close clasped to her most beloved neck,
that I may most lovingly kiss her with all the kisses
of My mouth. And be it known to you that while I
am amidst the delights of these holy caresses which
surpass all sweetness, I consider that My mother is a
tree of life, and Myself on her as its fruit ; and I am
her own heart in her breast, or her soul in the midst
of her heart, so that as her going serves both her and
Me without My troubling Myself to take a single step,
so her will serves us both without My producing any
act of My will about going or coming. Nor do I ever
take notice whether she goes fast or slow, hither or
thither, nor do I enquire whither she means to go,
contenting Myself with this, that go whither she
please I go still locked in her arms, close laid to her
beloved breasts, where I feed as amongst lilies. O
Divine Child of Mary ! Permit my poor soul these
outbursts of love : Go then soul, O most amiable
dear little babe, or rather go not, but stay, thus holily
fastened to your sweet mother's breasts. Go always
in her and never be without her whilst thou remainest
a child ! *O how blessed is the womb that bore Thee and
the breasts that gave Thee suck !* The Saviour of our
souls had the use of reason from the instant of His
conception in His mother's womb, and could make all
this discourse ; so could even the glorious St. John,
His forerunner, from the day of the holy Visitation,
and though both of them, as well in that time as all
through their infancy, were possessed of liberty to
will or not to will, yet, in what concerned their external
conduct, they left to their mothers the care of doing
and willing for them what was requisite.

Thus should we be, Theotimus, pliable and tractable
to God's good pleasure, as though we were of wax,
not giving our thoughts leave to wander in wishing
and willing things, but leaving God to will and do

them as He pleases, *throwing upon Him all our solicitude, because He has care of us*, and the holy Apostle says : And note that he says *all our solicitude*, that is as well that which concerns the event, as that which pertains to willing or not willing. For He will have a care of the issue of our affairs, and of willing that which is best for us.

Meanwhile let us affectionately give our attention to blessing God in all His works, after the example of Job, saying : *The Lord gave and the Lord hath taken away, the name of the Lord be blessed !* No, Lord ; I will no events, for I leave You to will them for me at Your pleasure, but instead of willing the events I will bless You because You have willed me. O Theotimus ! what an excellent employment of our will is this, when it gives us the care of willing and choosing the effects of God's good-pleasure in order to praise and thank this good-pleasure for such effects.

AUGUSTINE BAKER

1575–1641

AUGUSTINE BAKER, called 'the Venerable,' was born of Protestant parents at Abergavenny in 1575 and was baptized David. He went to school at Christ's Hospital, then read law at Oxford, and became a member of Clifford's Inn and the Middle Temple. After a spiritual crisis he became a Catholic and joined the Benedictines in the famous monastery of St. Justina at Padua. After being aggregated to the English congregation O.S.B., he was engaged in historical research and as a missionary and chaplain in Devonshire, and then was attached to the convent of English Benedictine nuns at Cambrai. He did most of his writing there, where he remained for about nine years and was the friend and director of the well-known mystic Dame Gertrude More. Later he passed some years at Douai, and then returned to London, where he died of the plague in 1641.

Father Baker's numerous treatises in manuscript were studied by another Benedictine monk, Seremus Cressy, who published an abstract of them under the title of *Sancta Sophia*, which has become a classic. In spite of certain defects as a practical work of spiritual direction it is regarded by many as the best English work of the kind. Its chief characteristic is the extreme importance attached to interior prayer. For Father Baker prayer is indeed all, the object and end of our strivings and our mortifications, the touchstone of the spiritual life.

Other published works of less importance are the interesting *Secretum sive mysticum*, a commentary on *The Cloud of Unknowing* (see page 86) and thinly-veiled spiritual autobiography, and a Life of his dear disciple Gertrude More.

WORKS : *Holy Wisdom (Sancta Sophia).* Edited by Abbot Sweeney.

Confessions of the Venerable Father Augustine Baker. Edited by Dom Justin McCann.

Life of Father Augustine Baker. Edited by Dom Justin McCann.

All published by Burns Oates & Washbourne.

THE PRAYER OF ASPIRATIONS

FATHER BAKER distinguishes three degrees of prayer or rather three states of prayer : First degree, discoursive prayer or meditation. Second degree, the internal affective prayer or the prayer of ' immediate acts or somewhat forced affections of the will.' Third degree, the prayer of pure contemplation, or ' the prayer of aspirations as it were naturally and *without any force* flowing from the soul, powerfully and immediately directed and moved by the Holy Spirit.' The first prayer corresponds, he says, to the purgative life, the second to the illuminative life, the third to the unitive life. (Compare the prayer of aspirations as exposed by the great French mystic, the Carmelite Jean de Saint Sanson.)

1. Internal prayer proper to the state of active contemplation[1] consists of certain most purely spiritual operations of the will, longing and thirsting after God, and a union with Him in the supreme point of the spirit, where His most proper dwelling is.

2. These perfect operations are by spiritual authors severally named, as elevations, inward stirrings of the spirit, aspirations, etc. ; we will in the following discourse make use, for the most part, of this last term of aspirations, as most proper in a general notion to

[1] By active contemplation Father Baker understands any infused contemplation which is not entirely or perfectly passive. This is clear from the present chapter as well as from the previous chapters.

express the said operations. For by them the soul in a holy ambition doth aspire to raise and elevate herself out of the inferior nature and to mount to the *apicem spiritus*, which is God's throne. . . .

3. Now these aspirations are certain short and lively affections of the soul, by which she expresses a thirsty longing after God, such as these : My God, when shall I love Thee alone ? When shall I be united to Thee ? Whom have I in Heaven or earth, but Thee alone ? O that Thou wouldst live and reign alone in my soul. O my God, Thou alone sufficest me. Dost Thou not know, O my God, that I love Thee only ? Let me be nothing and be Thou all ; O my God. O love ! O love ! O infinite, universal good ! When shall I come and appear before the face of Thee, O my God ? Let me love Thee only and that is sufficient. When shall I die, that my God alone may live in me ? etc.

4. Now the same affections (such as these) that are used in the prayer of aspirations, may also be used, forasmuch as concerns the expression and sense of them, in the exercise of immediate acts, and even in meditation itself ; but yet the manner by which the soul produces the said affections are, in many respects, different in perfect and imperfect souls, and the said aspirations are of a quite different nature from other forced immediate acts of the will.

5. For first, such fervorous affections, tending directly and immediately to God, are the entire matter in the exercise of aspirations. Whereas in immediate acts they are only now and then interlaced ; but the ordinary matter of such acts is the doing or forbearing anything for God, as in acts of resignation, etc.

6. Secondly, in those immediate acts and affections, in which there are no images of creatures involved, but which respect God immediately, He is represented by some distinct image or express notion in the mind, as by some special attribute, perfection, similitude,

etc. But a soul, after a long practice of internal abstraction and renouncing of all representations of God, contents herself with such a confused notion of Him as may be apprehended by an obscure general faith ; that is to say, not simply and absolutely with no kind of image at all (for that is supposed inconsistent with the operations of the soul whilst it is in a mortal body), but not with a distinct, formal, chosen, particular image ; for all such, offering themselves, are rejected by perfect souls. So that if they were to give an account of what they conceive in their minds when they intend to think of God, all they could say would be : ' God is nothing of all that I can say or think, but a Being infinitely beyond it, and absolutely incomprehensible by a created understanding. He is what He is and what Himself only perfectly knows, and so I believe Him to be and as such I adore and love Him only ; I renounce all pretending to a distinct knowing of Him, and content myself with such a blind believing. Now though imperfect souls also (especially those that are learned) do acknowledge this negative apprehension of God to be only truly proper and perfect, yet by reason that gross images are not yet chased out of their minds, they cannot in their internal operations proceed constantly according to such an acknowledgement. Such an obscure negative object will not ordinarily move their affections, whereas no other but such an object will move the affections of perfect souls.

7. Thirdly, proper aspirations in perfect souls have no precedent discourse at all, as acts have at least virtually ; neither does the will in aspirations intend to employ or make use of the understanding, for they are sudden elevations of the will without any previous motive or consideration.

8. Fourthly, immediate acts are not only produced with deliberation or choice, but ordinarily with some degree of force used upon the will. But aspirations

proceed from an interior impulse, indeliberately and as if it were naturally flowing from the soul, and thereby they show that there is in the interior a secret, supernatural, directing principle, to wit God's Holy Spirit alone, teaching and moving the soul to breathe forth those aspirations, not only in set recollections, but almost continually. Now this does not infer that the Holy Spirit is not also the principle of all other good acts and affections of the will (for none of them have any true good in them further than they proceed from this divine principle) ; but in them the will doth previously and forcibly raise itself up to the producing them, in which likewise much of nature is mixed ; and so the Holy Spirit is not so completely and perfectly the fountain of them as He is of aspirations.

9. Fifthly, in case that a soul, whose constant exercise as yet is but immediate acts or meditation, do sometimes merely by an internal impulse produce such indeliberate aspirations, yet they are neither so pure and subtile, neither will they continue any considerable time ; but the present invitation or fervour being passed, the soul must be content to return to her inferior exercises, or if she will needs force herself to continue them, her recollections will become dry, insipid, and without any profit at all.

10. Lastly, aspirations (when they are a soul's usual exercise) do proceed from a more habitually perfect ground, and therefore are far more efficacious and noble than immediate acts ; and moreover, there being no violence at all used in them, they are much more frequently and continually produced, and consequently do procure more new graces and merits, and do far more increase the habit of charity.

11. No man can limit the time how long souls are to continue in inferior exercises before they will be enabled and made ripe for so sublime a prayer, and therefore there is no relying upon the instructions, practice or examples of any. All depends : First

degree, upon the industry or diligence of souls in prayer and mortification. Second degree, somewhat upon their special temper and disposition. Third degree, likewise upon the advantage that they may have from solitude and abstraction of life. Fourth degree, but principally upon the free grace and good pleasure of God, who may and does, by ordinary or extraordinary means, call and enable souls to aspirations, some sooner and some later.

12. In passing from the exercise of acts to aspirations there is, as to the manner of cessation of forced acts, great variety in souls ; for some will have their morning recollections to be suddenly and entirely changed from forced acts to aspirations, and also the ability for a longer continuance increased ; whereas the evening recollections will be little altered. ,In other souls (and this is most ordinary) their exercising of acts will grow by degrees more and more aspirative, and this will happen sometimes in the beginning, sometimes in the middle, and sometimes in the conclusion of their recollections. And thus they in their recollections will get more and more ground upon acts, diminishing both the frequency and constraint or difficulty of them, and increasing aspirations, till in progress they become wholly aspirative. . . .

15. When the exercise is become wholly aspirations, all the change that will happen afterward will not be in the substance of the exercise, but only in the degrees of purity, subtilty, and spiritualness of those aspirations, for there is no active exercise more sublime.

16. A soul may come to that state that she may constantly breathe forth aspirations, and yet, sufficiently to the discharge of her obligations, either work, read, hearken to a lesson recited, say or hear Mass, communicate, etc. ; neither is there any negligence or irreverence committed by so doing ; for by no operation so much as by aspirations doth the soul enjoy a sublime and perfect union in spirit with God,

which is the end of all exercises and duties. And
this is the meaning of that saying of the mystics :
' In God nothing is neglected.' Yea, some of them
do affirm that there may be souls so perfect, that even
amidst the noises and disorders of a camp they may,
without neglecting their present duty there, most
efficaciously exercise themselves in aspirations to God.

17. Now the reason why aspirations are less hindered
by external businesses than are meditation or immediate
acts is, because in aspirations the understanding is
scarce at all employed, and therefore may well enough
attend to other businesses ; and moreover, the will,
abounding and even overflowing with Divine love,
will not find herself interested in affection, and
consequently not distracted by such employments.

LOUIS LALLEMANT

1587–1635

LALLEMANT was born at Châlons-sur-Marne in 1587 and was educated in the Jesuit college at Bourges. After a blameless youth he joined the Society at Nancy in 1605 and did his philosophy and theology at Pont-à-Mousson. After teaching these subjects and mathematics he was appointed novice-master at Rouen, and then instructor of those undergoing their three years' 'second novitiate' (tertians). It was then particularly that he showed his holiness and mastery of the spiritual life. He died at the age of forty-eight.

Lallemant wrote nothing himself, but his teaching was carefully taken down by some of his subjects, notably Fathers Rigolene, Huby, and Surin, and afterwards published by Father Champion. The directing ideas on which he loved to dwell may be summed up thus : (1) The need to seek perfection with all one's heart and powers ; (2) The great esteem due to contemplation, for ' a man of prayer will do more in a year's apostolate than another in a lifetime.' Degree of activity must be conditioned by one's degree of interior life, in the same ratio ; (3) The heart must be purified and schooled until it is amenable only to supernatural principles ; (4) Loving submission to the guidance of the Holy Ghost. In this connection Lallemant made a deep study of the gifts of the Holy Ghost, which has been well approved in our day by differing ' schools ' of spirituality.

WORKS : *La Doctrine Spirituelle* (nouvelle edition par le Père Pottier, S.J.)

TRANSLATION : *The Spiritual Teaching of Father Louis Lallemant.* Edited by Alan G. McDougall. (Burns Oates & Washbourne).

SUBMISSION TO THE HOLY GHOST

THE two elements of the spiritual life are the cleansing of the heart and the direction of the Holy Spirit. These are the two poles of all spirituality. By these two ways we arrive at perfection according to the degree of purity we have ˚attained, and in proportion to the fidelity with which we have co-operated with the movements of the Holy Spirit and followed His guidance.

Our perfection depends wholly on this fidelity, and we may say that the sum of the spiritual life consists in observing the ways and the movements of the Spirit of God in our soul, and in fortifying our will in the resolution of following them, employing for this purpose all the exercises of prayer, spiritual reading, the sacraments, the practice of virtues and good works.

§

Some exercise themselves in many commendable practices and perform a number of exterior acts of virtue ; thus their attention is wholly given to material action. This is well enough for beginners, but it belongs to a far higher perfection to follow the interior attraction of the Holy Spirit and be guided by His direction. It is true that this latter mode of acting yields less sensible satisfaction, but there is more of the interior spirit and of virtue in it.

§

The end to which we ought to aspire, after having for a long time exercised ourselves in purity of heart, is to be so possessed and governed by the Holy Spirit that He alone shall direct all our powers and all our senses, and regulate all our movements, interior and exterior, while we, on our part, make a complete surrender of ourselves, by a spiritual renunciation of our own will

and our own satisfaction. We shall thus no longer live in ourselves, but in Jesus Christ, by a faithful correspondence with the operations of His Divine Spirit, and by a perfect subjection of all our rebellious inclinations to the power of His grace.

§

Few persons attain the graces which God had destined for them, or, when they have lost them, succeed afterwards in repairing the loss. The majority lack the necessary courage to conquer themselves, and the fidelity to trade with advantage in the gifts of God.

When we enter on the path of virtue, we walk at first in darkness ; but if we follow the leading of grace faithfully and perseveringly, we shall infallibly attain a great light both for our own guidance and for that of others.

We wish to become saints in a day ; we have not patience to await the ordinary course of grace. This proceeds from our pride and cowardice. Let us only be faithful in co-operating with the graces which God offers us, and He will not fail to lead us to the fulfilment of His designs.

ZEAL WITHOUT PRAYER IS DEAD

WITHOUT a solid devotion and a close familiarity with God, we cannot carry on our functions nor discharge them properly. The prophets, Apostles, and other saints have wrought wonders, because they were inspired by God, and conversed familiarly with Him.

Saints succeed in everything, because by their prayers they obtain a benediction and a virtue which render their labours efficacious. Although they be infirm and suffering from constant ill-health, like St. Gregory and St. Bernard, they effect wonders.

In vain we toil and form great projects for the glory of God and the service of souls ; without prayer nothing can be hoped from our labours and undertakings ; but with the gift of prayer, we may do great things, even in matters of prudence and the management of affairs.

Let us season our exertions in behalf of our neighbour with recollection, prayer, and humility ; God will make use of us for great ends, although we may not possess great talents.

We ought to undertake nothing, whatever the matter be, without having disposed ourselves thereto by prayer.

§

It is to God we ought to look for every success in our employments. We are His instruments, and we work under Him as under a master-architect, who, directing singly the whole design, allots to each one his task, according to the end he proposes, and the idea he has conceived. Thus we shall produce the more fruit the more united we are to God, and the more we yield ourselves to His guidance, always supposing we possess the talents and the capacity requisite for the active service of our neighbour. Now it is prayer that unites us to God. It is by this holy exercise that we dispose ourselves to receive the impression and movement of grace, as instruments to work out His designs.

§

As there are certain humours which cause the death of the body when they gain too much strength and are too abundant, so in the religious life, when action is carried to excess, and is not moderated by prayer and recollection, it infallibly quenches the spirit.

And yet there will sometimes be found persons who, being occupied whole days and years in study and in the turmoil of exterior employments, will feel it difficult to devote a quarter of an hour a day to spiritual

reading ; and then how is it possible they should become interior men ? Hence it is that we gain no fruit, because our ministrations are not animated by the Spirit of God, without which, with all our talents, we cannot attain the end we are aiming at, and are but as *sounding brass or a tinkling cymbal.*

An interior man will make more impression on hearts by a single word animated by the Spirit of God, than another by a whole discourse which has cost him much labour, and in which he has exhausted all his power of reasoning.

THE BEGINNING OF CONTEMPLATION

WHEN, after a long cultivation of purity of heart, God would enter into a soul and manifest Himself to it openly by the gift of His holy presence, which is the first in order of His supernatural gifts, the soul finds itself so delighted with this new state, that it feels as if it had never known or loved God before. It is astounded at the blindness and stupidity of men ; it condemns the indolence and languor in which we generally pass our lives ; it deplores the losses it believes itself to have incurred by its slothfulness ; it accounts the life it has hitherto led as not deserving the name of life, and that it is only just beginning to live.

§

In vain do we labour to have this sense of the presence of God unless He Himself bestows it upon us. It is a pure gift of His mercy. But when we have received it, by that presence and in that presence we see God and the will of God in our actions, as we behold at one and the same time the light and the body which it enables us to see. This grace is the fruit of great purity of heart, and leads the soul to close

union with God. He bestows it upon us, when, on
our part, we do what we can and ought to do.

Were we fully possessed with God, we should be able
to practise incessant prayer. It occasionally happens
that some passion, or resentment, or vexation of mind,
so possesses us, that we are altogether engrossed by it
for two or three days together, and think of scarcely
anything else. Not an hour in the day passes without
our experiencing this ill-feeling ; and though we fancy
we resist it, yet if God were to show us the real dis-
position of our heart, we should see that we had no
desire to be free from it, and yielded it some sort of
secret consent.

In like manner, if we had a tender devotion to our
Lord, to the Holy Sacrament of the altar, we should
think of Him a thousand times a day. If our heart
were wholly occupied with God, we should cherish an
unceasing remembrance of Him, and should experience
no difficulty in realizing His presence. Everything
would serve to raise us to Him, and the least occasions
would excite our fervour.

WHAT CONTEMPLATION DOES

WE see in the first Epistle of St. Paul to the Corinthians
that the most marvellous gifts of God were commonly
granted to the first Christians, the gift of tongues, of
healing the sick, of working miracles, of prophecy, and
of discernment of spirits ; and the holy Apostle exhorts
the faithful to desire these spiritual gifts, and particu-
larly that of prophecy, which consists not only in
predicting things to come, but also in understanding
the Scriptures, in expounding them, and instructing
the people.

Nowadays, if anyone aspires after some gift of prayer
a little above the common order, he is plainly told that
such things are extraordinary gifts which God gives only

when He will and to whom He will, and that we must not desire them nor ask for them : thus the door of these gifts is for ever shut against him. This is a great abuse. True it is that we must not of ourselves intrude into these kinds of prayer ; but at the same time we ought not to refuse them when God offers them, nor actually do anything which may have the effect of preventing His admitting us to them when He pleases.

§

Meditation wearies and fatigues the mind, and its acts are of short duration ; but those of contemplation, even such as is of a common order, last whole hours without labour and without weariness ; and in the purest souls contemplation may easily continue several days together, in the very midst of the world and the engagements of business. In the state of glory, the first act made by a holy soul on beholding the beatific vision will last to all eternity without satiety or fatigue, ever the same and ever new. Now contemplation is a participation in the state of glory. It resembles it in its facility and duration. It injures neither health nor strength.

§

Contemplation opens a new world to the soul, with the beauty of which it is enraptured. St. Teresa, when passing out of prayer, used to say that she came from a world incomparably more vast and beautiful than a thousand worlds such as this.

St. Bernard, returning from converse with God, went back with regret to the society of men, and dreaded attachment to creatures as hell itself. That holy priest, John of Avila, on leaving the altar, could scarcely endure intercourse with the world.

In contemplation a pure soul discovers without labour, or any exertion of its powers, truths which throw it into ecstasy, and which, withdrawing it from

all the operations of the senses, cause it to experience within itself a foretaste of paradise.

§

Contemplation leads souls to heroic acts of charity, zeal, penance, and other virtues, as, for example, martyrdom. The saints who had received this gift from God, desired their sufferings to be increased tenfold ; and to form these desires they had not to undergo those struggles and repugnances which we commonly experience in our good resolutions. They found therein nothing but consolation.

CONTEMPLATION NECESSARY TO ACTIVITY

CONTEMPLATION, far from hindering zeal for souls, on the contrary augments it by three considerations, of which it gives the mind a vivid appreciation.

First, that souls are capable of possessing God ; and that viewed in this light, there is not one which is not incomparably more precious than the heavens and the earth with all their glory and riches.

Secondly, that souls belong to the Son of God ; that He has given His life to redeem them ; that He has washed them in His Blood ; and that being His inheritance and His kingdom, there is no labour which should not be undertaken, no sufferings which should not be endured, for their salvation and perfection.

Thirdly, what is the state of a soul in mortal sin ! how wretched it is, and nigh unto hell !

These considerations it was that made St. Paul desire to be anathema for his brethren, and has caused many saints to wish that they might suffer, if God had permitted it, the pains of hell without sin so that they might prevent the loss of a single soul.

Such were the sentiments of St. Catherine of Siena, St. Catherine of Bologna, Alphonsus Rodriguez.

§

Without contemplation we shall never make much progress in virtue, and shall never be fitted to make others advance therein. We shall never entirely rid ourselves of our weaknesses and imperfections. We shall remain always bound down to earth, and shall never rise much above mere natural feelings. We shall never be able to render to God a perfect service. But with it we shall effect more, both for ourselves and for others, in a month, than without it we should accomplish in ten years. It produces acts of great perfection, and such as are altogether pure from the alloy of nature ; most sublime acts of the love of God, which we perform, but very rarely without this gift ; and, in fine, it perfects faith and all virtues, elevating them to the highest degree to which they are capable of rising.

§

If we have not received this excellent gift, it is dangerous to throw ourselves too much into active occupations of charity towards our neighbour. We ought to engage in them only experimentally, unless imposed upon us by obedience, otherwise we ought to occupy ourselves but little in external employments, the mind in such case having enough to do in acquiring self-knowledge, in purifying continually the natural acts and sentiments of the heart, and in regulating the interior, so that we may walk always in the presence of God.

WHAT CONTEMPLATION IS

CONTEMPLATION is a perception of God or of Divine things, simple, free, penetrating, certain, proceeding from love, and tending to love.

1. This perception is simple. In contemplation we do not exercise the reason, as in meditation.

2. It is free ; because to produce it the soul must be liberated from the least sins, irregular affections, eagerness, and unprofitable and disquieting cares. Without this, the understanding is like a bird, tied by the feet, which cannot fly unless it be set at liberty.

3. It is clear and penetrating, not as in the state of glory, but as compared with the knowledge we have by faith, which is always obscure. In meditation we see things only confusedly, as it were from afar off, and in a dryer manner. Contemplation enables us to see them more distinctly, and as it were close at hand. It enables us to touch them, feel them, taste them, and have an inward experience of them. To meditate on hell, for instance, is to see a painted lion ; to contemplate hell, is to see a living lion.

4. It is certain ; because its objects are the supernatural truths which the Divine light discloses to it ; and when this disclosure is made immediately to the understanding, it is not liable to error. When it is made either through the senses or through the imagination, some illusion may at times mix with it.

5. It proceeds from love, and tends to love. It is the employment of the purest and the most perfect charity. Love is its principle, its exercise, and its term.

§

The gifts of the Holy Spirit which serve to contemplation are particularly those of understanding wisdom, and knowledge, in regard to the intellect ; and those of piety and fear, in regard to the will.

By the gift of knowledge, we know creatures, and despise them, beholding their frailness, their fleetingness, their nothingness. By the gift of wisdom we know the greatness of God and of heavenly things ; and hence we are led to detach ourselves from all

affection to creatures in order to unite ourselves solely to God. The effect is pretty much as when one has just been seeing the Louvre or some extraordinary picture. The mind, filled with these beautiful objects, deigns not so much as to cast a look at some peasant's hut or some schoolboy's daub. Thus a soul to which God manifests Himself in prayer ceases to find anything great on earth. St. Anthony possessed so rare a gift of contemplation that he passed whole nights in this holy exercise without perceiving that he had spent a moment in it ; and on receiving letters from the Emperor Constantine, did not deign even to send him one word in reply.

JOHN JOSEPH SURIN

1600–1665

FATHER SURIN, who was born at Bordeaux in 1600, came under the direction of Father Lallemant at Rouen and was afterwards sent to Marenne, where he came into contact with such chosen souls as Madeleine Boinet. Two years later, because of his outstanding goodness and knowledge of supernatural things, the Jesuit authorities picked him out for a very difficult mission, namely, to exorcize a certain Joan of the Angels and other Ursuline nuns at Loudun who were said to be possessed and had proved unamenable to previous exorcisms. Father Surin was no more successful and fell a victim to his own devotion to duty ; long association with the unfortunate nuns upset his nerves and he was recalled to Bordeaux. For nearly twenty years he seemed as though he himself were possessed, undergoing awful trials and sufferings which he accepted as health-giving humiliations.

But in the evening of his life the sky cleared and was irradiated : in 1658 his troubles were succeeded by consolations, and he began first to dictate and then to write down his exalted spiritual teaching. His last years were passed peacefully in constant union with God, that reward of perfect love which he so well describes in his treatise on the love of God.

Father Surin was a faithful follower of Lallemant and stresses the need of complete docility to the slightest breath of the Holy Ghost. Like him, too, he insists repeatedly on right intention and disinterested love : God and God only must be loved in all things. Surin, like other French mystics, writes of exalted matters clearly and without the use of the confusing and equivocal terms which are found in some mystical authors. He can be understood by any reader of good will.

WORKS : *Le catéchisme spirituél.*
Le guide spirituel.
Fondements de la vie spirituelle. A kind of commentary on certain texts from the *Imitation of Christ.*
Questions importantes sur l'amour de Dieu. Ed. par le Père Pottier (Paris, 1930).
Recueil de lettres spirituelles. Ed. par le Père Cavallera. (Paris, 1925).

THE WAY TO DISINTERESTED LOVE

WHAT IS THIS WAY?

IT is ceaselessly to examine the four chief passions of the human heart, watching whither they tend and what they seek, in order to keep them directed God-ward. There is no shorter way to transform and lose one's heart in God, for life consists in the use of those passions, desire, love, hope, and fear, to which may be added sadness and joy.

Clearly, then, he who wishes to rejoice in God only must keep an unremitting watch over his heart and must know how it is moved by the four passions, which are as the cardinal winds of this sea. When the soul is disquieted for want of something she must consider whither this wind is taking the heart, and if it be away from God that desire must be killed. If the soul is joyful, she must ask why she rejoices. It is because she has got something she wanted. Then she asks : Is that 'something' God? Is He better served and honoured on its account? Does it bring me nearer to Him? If not, it must be rejected. If our Lord comforts me and gives me help to be at peace in Him, then in my happiness I must remember that strong souls thrive in adverse conditions, so keeping myself humble and reminding my soul of the truth of the Cross and that God may be served in *all* things. . . .

By carefully watching the emotions of his heart and refusing those that are lower, natural, and imperfect in favour of those that are supernatural and Divine, the Christian succeeds infallibly, with the help of the Holy Ghost, in wanting, feeling, experiencing, nothing but God ; he finds that God is all in all to him, he is filled with Him. I have seen plenty of people who, in themselves weak, faulty, full of self-sufficiency and vanity, have succeeded in this way in being moved only by God, finding rest in correspondence with His will and His love.

There is recorded in the Life of St. Gertrude this testimony given by our Lord to St. Mechtilde, a nun in the same house : ' Gertrude by her faithfulness to this practice reached to so great a love of Jesus Christ and so carried Him in her heart that He was present so eminently nowhere else in the world, except in the Blessed Sacrament of the altar.'

I have often said before and I now say again that the God-given power of man's will and energy is such that, accepting available grace, he can by concentrating on this method, and in spite of weakness, aridity, and difficulties, reach a point where he has but one heart with Jesus Christ and is conscious of nothing in himself but Him. Bold directors, well instructed in the spiritual life, are a great help to this end. I repeat that you who read this, who feel yourselves so full of self and of temporal interests, can by the study of and correspondence with your will find yourselves at the end of a few years so different and so risen above what you are that you would not recognize yourselves—so forceful is the co-operation of grace when the soul is really directed towards God. (*Questions sur l'amour de Dieu*, book I, chapter vii, pp. 36–40.)

THE PERFECTION OF VIRTUE
BY CHARITY

SHOULD those who are 'perfect' give themselves solely to loving God to the exclusion of the practice of virtue ?

Three or four hundred years ago there were certain heretics (*illuminati*) who taught that the perfect man need not trouble about the virtues, but should confine himself to contemplation. *Homo perfectus licenciat a se virtutes*, 'The perfect man gets rid of the virtues,' they said, and persuaded people to neglect and forget them, giving themselves up to the freedom of the Spirit, following the currents of its breath, and despising the virtues as things below them. These people were condemned and their doctrine rejected by the Council of Vienne.

The source of their error was a high point of spirituality which they misunderstood and explained wrongly, namely, that when a man has long and carefully amended his faults and practised virtue, God gives his spirit a liking for Divine things, and, because he has already acquired habits of virtue, he is drawn to think only of uniting himself in love and following the promptings of grace, without paying much attention to distinct actions. Thus the soul ceases to watch her actions in detail. It is like the beginner in music, who learns to make the required notes with his voice or on an instrument, painfully, and one by one ; but when he is more expert he can play and sing without stopping to think what string to touch or note to sing, his mind occupied by something else. So the spiritual man at first concentrates on each virtue in particular according to the instruction he has received, but when once he has some facility in them the love of God turns his mind to the Divine perfections and he can follow the promptings of the

Holy Spirit without having consciously to consider the virtues.

Some mystical teachers maintain that the soul then need no longer advert to the particular motives of the virtues, that it is enough to follow the beckoning of the Divine Spirit, which will lead her to the heights. The heretics, misinterpreting these ideas, discarded care for the virtues in the name of a false liberty ; the truly religious man, on the contrary, never misses a chance of doing good or of using the best means : but, following the call of the Spirit, he brings all things under the motives of charity. Accordingly, it is not true to say that those who, filled with this motive alone, seek purely the good pleasure of God are negligent of the virtues and duties of Christian life.

The specific characteristic of the spiritual man is to clothe and perfect the virtues he practises with charity, so that they all savour of Divine love and the Divine will. It is like jam, which is different according to the fruit of which it is made ; but all jams are made and taste of sugar, it is that which makes them expensive and keeps them from going bad and makes them welcome at the tea-table. So with the perfect man who knows the disinterested love of God and seeks Him in all things : that man acts in such a way that each virtue keeps its own natural flavour, but is nevertheless so penetrated with charity and the motive of pleasing God that it seems to be all sugar, i.e. charity ; regard is no longer had to the particular motive of each virtue, but only to that which is uniquely important and weighty, the motive of Divine love. In this way every action of the soul, being as it were confected in charity, is not only cleansed from imperfection and preserved from corruption, but is made to taste deliciously of heavenly feastings, having received a transcendent and perfect quality from this good habit of the soul. But those holy ones who speak only of love, consider only love, and bring all

158 AN ANTHOLOGY OF MYSTICISM

under love as the proper element of the perfected,
do not for all that, as I have said, exclude that wise
fear which God gives to them to make their burning
love more cleansing and more ardent. (*Questions,*
book I, chapter ix, pp. 43–47.)

THE NEED FOR A HIGH IDEAL

FATHER SURIN here speaks of the common temptation
not to aim high enough in the spiritual life.

I know no more common or easier mistake or one
more difficult to remedy than that of setting a limit
to love and forming ideas that are totally inadequate
for our service of God. It is a usual thing for people
who have given themselves to God, become monks
or nuns, and wishing to be saints, soon to circumscribe
their ambitions and, instead of raising and extending
the scope of their love, to persuade themselves that
it is not necessary to go to the length of doing every-
thing for God actually and in detail as I have set
forth. They even say that such an undertaking is
illusory, and rarely set themselves to attempt it, not
reaching out towards perfection by recognizing no
other motive than that of God Himself.

We may be assured that St. Ignatius Loyola and St.
Teresa avoided this temptation : the one saw the
greater glory of God as the end of all things, the other
vowed always to choose the more perfect way. Were
I asked why, seeing that so many people have under-
taken the direct service of God, there are so few saints,
I would answer that the chief reason is that they have
given too big a place in life to indifferent things. They
do, without thinking, naturally, and for their own
satisfaction, a thousand little things, whatever little
good there may be in them being accepted without
reference to God, and without any effort to do *all*

for Him or to stop short at what does not conduce to
His perfect service.

I will say frankly that among those I know serving
God some have a continual thirst for Him ; they
watch over the purity of their motives and will not
dwell for a moment more than necessary on that
which is solely human. But I also know a large number
who, in the midst of good deeds, groan that they are
against their own interest, who are upset because they
don't get in one place the appreciation they receive in
another, who are loud in praise of their own mediocre
attainments, who take comfort from the thought that
everybody can't be perfect and that God leaves us
weak to keep us humble. This is true, but there is a
great difference between the weakness which God
leaves to souls for their own good and the feebleness
that is due to our own cowardice and irresolution.
These same people wilt under the burden of their
immortifications and exclaim : ' I'm not one of these
extraordinary souls. I haven't got any mystical gifts.
I don't fly so high. I stick to the well-beaten track of
the common way,' and persuade themselves that that
is the spirit of their vocation. To them I say : ' No ;
you haven't experienced these unions and heard these
high calls to God, and perhaps that is why it is so
difficult to calm you when you are put out by some
little thing, as when you have been slighted. If you
had a higher notion of perfection, if you looked always
to God and found comfort only in Him, you might
be admitted to these unions that make the heart so
strong that nothing human can disturb it.' It is not
good to wish for visions, revelations, and such out-of-
the-way things, but it is very good to have shown so
great a liberality towards God as to deserve a similar
return. If we choose poverty of spirit for His sake,
our Lord gives us richness of spirit. This poverty
consists in seeking self in nothing and in having a
faith that enables us, at the word and example of

Jesus and for His love, to throw aside the approval and comfort of men and all worldly advantages in order to accept the Cross and the duties of obedience.

Thereupon, without much reading and speculation and worrying of the head, the fountain of eternal life will flow for us ; its Divine enlightening comes to the soul not in the form of logical conclusions, but like spurts of grace, rivers of peace, torrents of blessing, and the will feels its potent fires whose flames leap to the heavens. (*Questions*, book I, chapter x, pp. 47–51.)

KNOWLEDGE BY LOVE

Question : How is it that love surpasses reason and understanding ?

Answer : Because in the first place the man who has experienced God by love can thus know more of what God is and advance towards Him than he can by the operations of his intelligence. For man can attain immediately to God by faith and be united to Him by love, this act of attainment being, as the mystics say, ' without go-between,' the soul remaining in the dark. So love far surpasses intelligence, reaching God and believing Him to be what He is without seeing Him as He is. That is why it is said that faith, however dim, exceeds all the notions that we can have of God (outside intuitive vision), because those who believe go to Him in the same way as do the blessed in Heaven who see Him : with this difference, that the blessed see Him as He is while the faithful ones believe Him as He is, not attaining the same notion of Him as those who actually see Him. Those who have compassed experimental love are united to Him as immediately as the blessed (but not so perfectly), and have thereby a higher and less imperfect idea of Him than all the philosophers and theologians in the world. Suppose a man proposed to give a

lecture on wine without ever having tasted it, all the book-learning he could amass would not make up for that lack ; he would still know nothing about it by contrast with the most ignorant French peasant who drinks it habitually.

Q. : What is the second way in which love surpasses intelligence ?

A. : When man seeks to come to God by way of his affections rather than his reasoning powers. It is certain that this way is more acceptable to God than speculation, however enlightened. Pico della Mirandolo, the quantity of whose teaching exceeded its quality, says after having written much : ' It is very silly to take so much trouble to come to the sovereign Good by means of study when assuredly He can be reached quicker by way of the affections ; with less trouble too, for nothing is so easy as to love.' St. Ignatius recommends this path to his religious, to whom he assigned a year after their studies for a more perfect approach to God : this period is called *schola affectus*, a school of affection. During it the religious, paying little heed to what he is able to learn by his intelligence, humbly, lovingly, and in a childlike spirit tries to drown himself in God by affection, without seeking on his own initiative to go beyond what the Faith tells him, blindly obedient to the virtue of faith, and dependent on a director, in order to teach his understanding to go to God in the same way as do the most simple folk.

True devotion does not consist in reasoning and speculation and a lot of brain-work, but in submission and humility of the heart which, being joined with love, not only unites the heart with God, but brings as well a great enlightening, for Divine love is a clear fire from which men receive great abundance of exalted thoughts : so much so that it is a bad mistake to cumber the mind with one's efforts to teach it too much. Love is an easy-flowing river which carries

treasures of understanding and knowledge gently to the soul. (*Fondements de la vie spirituelle*, book V, chapter ix.)

THE HAPPINESS OF THE PERFECTED SOUL

Question : What is man to hope for in this life when he gives himself up to goodness ?

Answer : The completest happiness that is possible in this world.

Q. : What does that happiness consist in ?

A. : In Divine union, the filling of his heart with God, and a plenteousness of the most desirable good things.

Q. : What are these good things ?

A. : Firstly, a fullness of God which the man experiences in all his powers, according to the word of St. Paul : *Ut impleamini in omnem plenitudinem Dei,* to the extent that the Divine Majesty rewards human effort to please Him by so penetrating the soul and its faculties that the man can say truthfully that he possesses God, that his very body is full with Him. Thus he finds that his deeds are superabundantly rewarded in this world, to say nothing of God's promises for the faithful in the life to come : ' Every one that hath forsaken houses or brethren or sisters or father or mother or wife or children or lands for My name's sake shall receive an hundredfold and shall inherit everlasting life.'

The second good is a continual converse and commerce of the soul with God and His Son, an association like that of a loving wife with her husband or of a child with the mother whose hand it holds. As the mother talks to the little one, helps it to walk, advises, warns, and caresses it, so God leads the soul, warns, advises, speaks to her, and from time to time caresses her in a way that is beyond the appreciation of those

who have not experienced it. The soul is completely
happy and satisfied to find herself thus with God and
ever seeks more converse and delights, greater than a
king can have with his courtiers and subjects or a
passionate lover with his beloved. And beyond that
there are favours, intimacies, presents, secrets, which
man can neither explain nor understand, for he is
ravished and drowned in the joys which overwhelm
him. *Tunc videbis et afflues et mirabilitur et dilatabitur
cor tuum.*

The third thing proper to this state is a continual
immersion of the essence of the soul in the Divine
essence, as it were in a deep pool of peace and love,
the soul bathing herself in the light and fire of God
like a fish in the sea. As the fish is born to the freedom
of the whole ocean, and can swim whithersoever he
will without let or hindrance, so the soul has the
boundless immensity of God in which deliciously to
lose herself at any moment. (*Fondements*, book V,
chapter xiv.)

MARY OF ST. TERESA

1623–1677

MARY PETIT belonged to a well-to-do mercantile family of Hazebrouck, where she was born in 1623. After a childhood marked by alternations of religious fervour and lassitude she made several fruitless attempts to become a nun ; eventually, with some companions, she became a Carmelite recluse, first at Ghent and then at Malines, in a house called 'the Hermitage' near the Carmelite church. She was directed until her death by the prior provincial of that order, Father Michael of St. Augustine, a friar equally noted for learning and for holiness.

In her interesting biographical notes Sister Mary sets out at length the hard passive purgations by way of which God led her to the 'mystical marriage' in 1668. She was granted a special state of union with our Lady, and she describes this 'Marian life' in a way remarkable for a person of her modest condition.

Mary's writings, in Flemish, were published in two volumes by Father Michael at Ghent in 1683. They show her to have been a mystic of a high order, with much in common with the Frenchman, Brother John of St. Samson, who with Father Thibaut instituted the 'reform of Touraine' followed by the Belgian Carmelites at this time. She deserves to be better known, but it is only recently that parts of her writings have been translated into French, and this is the first appearance of any of them in English.

WORKS : *Vie Mariale de Maria a Sancta Téresia.* Fragments traduits par Louis van den Bossche. (Bruges, 1928.)

MYSTICAL UNION WITH MARY

THE pages from which these passages are drawn are
the more interesting because very few mystical writers
treat of this special union. They are naturally re-
miniscent of the treatises on our Lady of Blessed Louis
Grignon de Montfort.

There is sometimes shown and given to me a life
of the spirit in our Lady, a rest, enjoyment, fusion,
union in and with her.

This is how it happens. When my spirit is turned
to God in all simplicity, nakedness, and tranquillity,
resting in His Being without images by contemplation
of that absolute Being, my soul experiences at the
same time a union with and blossoming in Mary
inasmuch as she is united with God : so much so that
they seem to be but one object, almost like the sacred
humanity of our Lord which we contemplate united
with His Divinity and making of the two natures a
single Person and object of contemplation.

Of course there is no personal union of our Lady
with the Godhead as it is realized in Jesus Christ,
but only a holy and gratuitous union ; nevertheless
it is far, far more excellent with her than with any
other human creature, and so God shows her to the
soul who contemplates Him as perfectly one with
and united to Him, in such a way that the beholder
cannot distinguish any intermediary. I seem to
embrace and kiss our Lady with a marvellous losing
of my being in her and at the same time in God,
and sometimes it seems that I am enclosed within her
stainless loving heart. I am as it were drunken and
crazy with love for her and God together, giving
myself up to them entirely. Thus a Divine life both
compound and simple is realized, making a com-
pletely perfect way of loving our blessed mother.
But very few people know this life both for and in

Mary and for and in God experimentally, for it is given only to some of her true lovers, her darlings, the little ones whom she has chosen.

I am not at all surprised that our holy Peter Thomas was so preoccupied with our affectionate mother and that he seemed unable to forget his love and devotion for a single minute. His heart and all the powers of his soul were shot through with his knowledge and memories of her, and whatsoever he did or said was done and thought in her sweet name. For this reason he justly received its imprint on his heart. His long habit of ardent love made him to be as it were dissolved in her, one with her, and even for a time transformed in her, changed or absorbed in her love and at the same time in God—for where is one there is the other. (*Vie Mariale*, chapter ccviii, pp. 15–17.)

THE PRACTICE OF THE MARIAN LIFE

FURTHERMORE I was enabled by Divine grace to experience that this life in, with, and by Mary, simultaneously in, with, and by God, can be led interiorly with a simplicity and recollection of spirit almost as great as those of life in God alone. There is very little representation of the person of our Lady in the mind, for the soul regards her as united to and in God. The memory, understanding, and will are occupied with Mary and God in perfect repose, simplicity, and tenderness, to the degree that I can scarcely give any account of the mode and kind of ideas that occupy my soul. She knows in a confused way that the memory has a quite simple recollection of God and of Mary ; that the understanding has a clear and certain knowledge or contemplation of God present in God and Mary ; and that the will cleaves to them both with an intense calm love of the spirit.

I call this love ' spiritual ' because it seems to

operate in the higher part of the soul, detached from the sensible faculties and so better adapted to the intimate fusion and ' oneing ' in and with God and our Lady. The faculties themselves, having no other object or care than the knowledge and love of God and Mary, attain in a very perfect fashion to a firm cleaving of the whole soul to them, so that all three, God, our Lady, the soul, seem to be but one being, absorbed and dissolved in one another. This is the supreme end of the soul in the practice of the ' Marian life.' It is the unique result, or at least the chief effect, of love for our Lady, whereby she becomes a yet firmer bond between the soul and God. She is as it were a food and stimulus helping the soul more surely to reach the life of contemplation, union, and transformation in God and to remain firmly therein. (*Vie Mariale*, chapter ccxv, pp. 26–28.)

LOVE AND OUR LADY

It is the nature of love to form a union with and in the loved object, and it so penetrates and identifies the lover and the beloved that they seem to become one being. So it is that a great love for our Lady leads the soul to life in her, to union with her, and to other effects and changes conformable with its kind ; she finds herself in a state of perfection and efficiency, especially when the Divine Spirit guides and encourages her love.

When the Eternal Father sends into our hearts the spirit of His Son crying, ' *Abba !* Father ! ' when we are active and when we are passive, that is to say, when the tender love of a child for its Heavenly Father is realized in us, then the spirit of the Son produces the same effect in relation to our dear Mother. In this sense, the Father also sends the spirit of the Son into our hearts crying, ' Mother !

Mother !' There is one only spirit, the spirit of Christ, that arouses in our souls this love for and life in Mary, as it arouses love for and life in God, and both according to the manner in which they were realized in our Lord Jesus Christ. Here are mysteries, and I pass them over in reverent silence—but each one may experience them according to the measure of his love. (*Vie Mariale*, chapter ccxii, pp. 22-23.)

THE GOODNESS OF MARY

THE Well-beloved makes me see and understand with the enlightened eyes of faith the exaltedness, the might, the authority, the unexampled goodness of our Lady. God has set her unto everlastingness between Himself and man as a go-between, our advocate, a temperer of justice. It seems clear to me that He has made her the almoner of His grace and goodness towards men, and that nothing Divine comes freely and graciously to us except through her hands, as rain passes through a spout. It is His will to make her great in this way because she was found worthy among all women to be His Mother. Therefore has He made her like to Himself, adorned her with the attributes of Deity, and so united her to the Father that she sees one with God. . . .

This explains why our hearts are so enthusiastic in this love, and why—especially at the liturgical feasts of our Lady—we are aware of an almost uninterrupted warmth of heart : a Divine warmth, quite unlike anything in the natural order. I cannot lose the memory of it for a moment in a day, any more than I can forget God Himself. So am I swallowed up in her love and as it were consumed, for this interior affection is so strong and burning that I forget myself and all other created things : its flames bear up both

soul and body. Still, I don't know if it is all really like that.

I am so happy in Mary's might, majesty, and honour, in the inexpressible love of God for her, that I don't know what I can do or say to give thanks, praise, and worship to God and her proportionate to the enlightment and understanding of which I am conscious at this moment. But if I am powerless to act I can remain in the intimate quiet and rest of love. The spirit fails before the immensity of the mystery, which exceeds our comprehension and leaves it helpless ; but the will can still be busied in loving. (*Vie Mariale*, chapter ccx, pp. 18–20.)

THE ALMONER OF GRACES

WHAT numberless graces I see come down to us from God through the loving hand of Mary ! I indeed believe that He puts the salvation of every man into her keeping, and that it is in her care to lead each one to blessedness. Although she dwells in the consummation of contemplation of Diving Being she is not unmindful of our troubles and our needs, her motherly concern is always for us, to help and protect, physically and spiritually, all who call upon her trustfully. She is like the eagle which, for all her flight into the sun, still has an eye on her fledglings, that they want nothing and are in no danger. And we in our turn are bound to the service of this loving Mother, to honour her and return her love with the fond devotion of children.

This knowledge, and more like it, given to my soul increases, purifies, and gives stability to my respect and affection for our Lady ; the heart is smitten by a flame of love which lifts the soul forcefully towards consummation. Every new aspect of the wonders which God realizes in our Lady and of the love which

He bears her draws the soul to the heights and depths of wonderment, where she stays wrapped in contemplation, the mind powerless to understand the things that are unveiled.

But love is not yet satisfied. It seeks for names that will express Mary's grandeur and dignity, for words that will proclaim her praise and blessing ; it uses strange phrases in exaltation of her who is loved so much, just as the lover is driven to nonsense in praise of the beauty of his mistress.

The Well-beloved made me see in a glimmer of light that God is given more joy and has greater love for His mother than for all the other saints put together. (*Vie Mariale*, chapter ccxiv, pp. 24–26.)

INTELLECTUAL APPREHENSION OF MARY'S PRESENCE

THE love and kindness of our Lady for us are now made so clear and evident that there cannot be the least doubt or suspicion of illusion or other intrusion of natural considerations. She has taken me under her care and guidance as a schoolmistress takes the hand of a child to teach it to write : the child's hand does not budge except when the teacher moves it. So am I entirely under the tutelage of this most kind mother, and my eyes are fixed on her that I may see and do only what she wants and what pleases her best. And she shows me and explains what these things are in varying circumstances, what to do and what not to do. It seems impossible to act otherwise, for she is almost uninterruptedly before the eyes of my soul, drawing me on, smiling upon me, guiding me in the path of the Spirit and the perfecting of goodness. Never for a moment do I fail to realize her presence at the side of God.

This intellectual image and seeing has no materialistic element, introduces no multiplicity or mediate means into the soul : on the contrary, it is all achieved in a tranquil simplicity. (*Vie Mariale*, chapter ccxix, pp. 33–34.)

REST IN MARY'S ARMS

THIS life in our Lady and through her in God goes on. As before, it is a matter of humbleness, submission, obedience, and I remain like the child in the hands of its mother as I have described above.

To-day the disposition of my soul was towards a loving repose in her arms, cradled upon her lap, my heart running over with childlike affection. I have an intense desire to be pleasing to our Mother and to do whatever she likes most, and my attention is fixed on watching for interior indications of her preference in one direction or another. My heart is all ready to follow them and I am afraid neither of work nor difficulties nor fuss nor inconvenience nor anything in trying to fulfil her good pleasure.

I am simply overwhelmed with love for her when I think of her loving-kindness towards us, and my emotion to-day was so violent that I cried out aloud and carried on as if I were drunk or half lunatic. A little more and I should have to have had recourse to physical remedies, for it did not seem possible to bear more of that interior fire which was forcing these bodily manifestations from me. What strength cannot this Divine love give to the soul for the undertaking of great enterprises at the word of the Well-beloved and His mother, what perseverance in seeking to please them in the smallest things : barriers of fire and steel could not hold one back !

I am always conscious of Mary's encouraging and guiding hand in all that I do or refrain from doing,

and I look up to her with the eyes of a child to learn her will and pleasure in the slightest thing. I feel that I can say truly that she is mine and I am hers, all mine and all hers, for I am no longer my own.[1] (*Vie Mariale*, chapter ccxxv, pp. 43-44.)

[1] Written in October, 1668.

JOHN PETER DE CAUSSADE

d. 1751

ALL that is known of the life of Father de Caussade is that he joined the Society of Jesus at Toulouse in 1693, was teaching grammar in the Auch college in 1696, was later on rector at Albi, and that he died in 1751. He is justly accounted one of the best French spiritual writers. His *Instructions sur les divers états d'oraison* is a work much appreciated in these days. He shows in it, with a sureness of touch only to be gained from personal experience, how the soul progresses in prayer and how by an ever-increasing simplification of thoughts and affections and the help of Divine grace she reaches that precious prayer of the heart whose pregnant silence is so eloquent before God. Following Bossuet, Caussade insists on that doctrine of ' direct acts ' which is so often forgotten or disregarded. But *l'Abandon à la Divine Providence* is Caussade's master-piece, and nothing better has been written on the subject. There have been numerous French editions and it has been translated into many languages.

WORKS : *L'abandon à la Divine Providence. Instructions spirituelles en forme de dialogue sur les divers états d'oraison suivant la doctrine de Bossuet.*

TRANSLATIONS : *On Prayer.* Translated by Algar Thorold.

Self-abandonment to Divine Providence. Translated by the same.

Spiritual Letters. Translated by the same.

All published by Burns Oates & Washbourne.

THE MYSTERIES OF LOVE

FATHER DE CAUSSADE shows how Divine love is ministered to us by all created things, which communicate it in a hidden form.

What great truths are hidden from the eyes even
of Christians who think themselves very enlightened !
How few among them understand that all crosses,
all actions, all *attraits* that are in the Divine Order
give us God in a way that can be best explained by
comparison with the most august mystery of all !
Yet, what is more certain ? Does not reason, as
well as faith, reveal to us the real presence of the
Divine love in all creatures and in all the events of
life as indubitably as the word of Jesus Christ and
the Church reveal to us the presence of the sacred
flesh of our Saviour under the Eucharistic Species ?
Do we not know that by all these creatures and all
these events, the Divine love desires to unite Himself
to us, that He has produced, ordained or permitted
everything that surrounds us or happens to us in
view of this union, the sole end of all His designs,
that He uses, to attain this end, the worst as well as
the best of creatures and the most disagreeable as
well as the pleasantest events, and that the more
naturally repellent the means of that union, 'the more
meritorious it becomes ? But if all this is true, why
should not every moment of our lives be a sort of
communion with Divine love continuously producing
in our souls the fruits of that communion in which we
receive the body and blood of the Son of God ? The
latter, truly, has a sacramental efficacy lacking to the
former, but on the other hand how much more fre-
quently the former can be renewed and how greatly
can its merit grow through the perfection of the
dispositions in which it is performed ! How true that
the holiest life is mysterious in its simplicity and its
apparently humble state. Divine banquet, perpetual
festival . . . God ever given and received under appear-
ances of the greatest weakness and nothingness ! . . .
God chooses what is blameworthy to the natural
judgement and what human prudence leaves on one
side. Of such things God makes mysteries and

sacraments of love, and gives Himself to souls to the full extent of their faith through the very medium which might appear to injure them.

THE STATE OF ABANDONMENT

Sacrificate sacrificium justitiae et sperate in Domino : ' Offer a sacrifice of justice,' says the Prophet, ' and hope in the Lord.' This means that the great and solid foundation of the spiritual life is to give oneself to God in order to be the subject of His good pleasure in everything internal and external, and afterwards to forget oneself so completely, that one considers oneself as a thing sold and delivered to the purchaser to which one has no longer any right, in such a way that the good pleasure of God makes all our joy and His happiness, glory and being become our sole good.

This foundation being laid, the soul has nothing to do save to pass all her life in rejoicing that God is God, abandoning herself so completely to His good pleasure, that she is equally content to do this or that, or the contrary, at the disposal of God, without reflecting on the use which His good pleasure makes of her.

To abandon oneself ! This then is the great duty which remains to be fulfilled after we have acquitted ourselves faithfully of the duties of our state. The perfection with which this duty is accomplished will be the measure of our sanctity.

A holy soul is but a soul freely submitted to the Divine will with the help of grace. All that follows this simple acquiescence is the work of God and not of man. The soul should blindly resign herself in self-abandonment and universal indifference. This is the only disposition asked of her by God ; the rest belongs to Him to choose and determine according to His designs, as an architect selects and marks the stones of the building he proposes to construct.

We should then love God and His Order in every-
thing, and we should love it as it presents itself,
desiring nothing more. That these or those objects
should be presented is no concern of the soul, but of
God, and what He gives is best. The whole of
spirituality can be expressed in abridged form in this
maxim : we should abandon ourselves purely and
entirely to the Order of God, and when we are in
that Order we should, with a complete self-forgetfulness,
be eternally busied with loving and obeying Him,
without all these fears, reflections, returns on ourselves,
and disquietudes which sometimes result from the care
of our own salvation and perfection. Since God
offers to manage our affairs for us, let us once for all
hand them over to His infinite wisdom, in order to
occupy ourselves only with Himself and what belongs
to Him.

Come, my soul, let us pass with head erect over
all that happens within us or outside us, remaining
always content with God, content with what He'
does with us and with what He makes us do. Let
us be very careful not to engage imprudently in
that multitude of restless reflections which like so
many paths leading nowhere present themselves to
our mind to make it wander and stray endlessly
to our sheer loss : let us pass this labyrinth of our
own self-love by vaulting over it and not by following
it ort in all its interminable details.

Come, my soul, let us pass beyond our languors,
our illnesses, our aridities, our inequalities of humour,
our weaknesses of mind, the snares of the devil and of
men with their suspicions, jealousies, sinister ideas
and prejudices. Let us fly like the eagle above all
these clouds, our gaze ever fixed on the sun and on
its rays, which are our duties. We feel all these
miseries, and it does not depend on us to be insensible
to them, but let us remember that our life is not a
life of feeling. Let us live in that higher region of the

soul where the Will of God produces His eternal
operation, ever equal, ever uniform, ever immutable.
In that spiritual home where the Uncreated, the
Formless, the Ineffable, keeps the soul infinitely
removed from all the specific detail of created shadows
and atoms, we remain calm even when our senses are
the prey of the tempest. We have become independent
of the senses ; their agitations and disquietudes, their
comings and goings and the hundreds of metamor-
phoses they pass through do not trouble us any more
than the clouds that darken the sky for a moment
and disappear. We know that everything happens in
the senses as in the air where all is without suite or
order, in a state of perpetual change. God and His
will is the eternal object which charms the heart in
the state of faith as in the state of glory. He will be its
true felicity ; and the state of the heart in glory will
have its effect on the whole of our material being,
at present the prey of monsters, owls, and weird
beasts. Under these appearances, however terrible
they may be, the Divine action will give to our being
a heavenly power and make it as shining as the sun ;
for the faculties of the sensitive soul and of the body are
prepared here below like gold, iron, fine linen and
precious stones. Like the material substrate of those
various things, they will only enjoy the splendour and
purity of their form after much manipulation and when
much has been destroyed and cut away. All that
souls endure here below under the hand of God has
no other purpose than to dispose them for this.

THE STATE OF ABANDONMENT

How detached from everything that one feels or
does must one be in order to walk by this path in
which one lives on God only and one's present duty.
We must cut off all more distant views, we must

confine ourselves to the duty of the present moment without thinking of what preceded it or what will follow it.

I suppose, of course, that the law of God is secure, and also that the practice of self-abandonment has made your soul docile to Divine action. You will have a feeling that will cause you to say : I feel at present an affection for this person or book, I would like to give or receive this piece of advice, to make such or such a complaint, to open myself to this soul or receive confidences from her, to give or do this thing or the other. You should follow this movement by the impression of grace without supporting yourself an instant by your own reflections, reasonings or efforts. We must apply ourselves to things for the time that God wishes without mixing ourselves up in them personally. The will of God is applied to us in the state of which we are speaking ; it should completely take the place of all our ordinary supports.

Each moment has its obligatory virtue to which the self-abandoned soul is faithful, yet she misses nothing of what she reads or hears ; the most mortified novice does not fulfil her duties better ; that is why these souls are now led to one book and now to another, or to make this or that remark on some trifling event. God gives them at one moment the desire to instruct themselves in what at another moment will support their virtue.

In all that they do, they feel only the attraction of the action without knowing why. All they can say reduces to this : I feel drawn to write, to read, to ask this question, to look at that object ; I follow this *attrait*, and God who gives it me makes in my soul a reserve-fund of such things to be in the future the means of further *attraits* which will enable me to make use of them in my own interest and that of others. This is what obliges such souls to be simple, gentle,

supple and mobile under the slightest, almost imperceptible, impressions of the Divine breeze.

In the state of self-abandonment the one rule is the present moment. The soul is as light as a feather, as fluid as water, simple as a child, as easily moved as a ball, so as to receive and follow all the impressions of grace. Abandoned souls have no more hardness or consistency than melted metal. For just as metal takes all the shapes of the mould into which it is poured, these souls adapt and adjust themselves as easily to all the forms which God wishes to give them. In a word, their disposition resembles that of the air which is at the service of all who breathe it and of water which takes the form of every recipient.

They present themselves to God like a perfectly plain and simple canvas, without concerning themselves to know the subject which it may please God to paint in their souls, for they trust themselves to Him, they are abandoned and wholly occupied with their duty, think neither of themselves nor of what is necessary for them, nor of how they are to procure it.

The more, however, they apply themselves to their little job, so simple, so hidden, so contemptible (as its outward appearance may be), the more God diversifies and beautifies it. On the background of simple love and obedience, His hands love to trace the most beautiful details, the most delicate and exquisite drawings, the most Divine figures : *Mirificavit Dominus Sanctum suum.* A canvas which is simply blindly abandoned to the painter's brush, merely receives each moment the impact of the brush. Similarly if a stone could feel it would feel nothing but the cruel point of the tool destroying it, but in no case the figure of which it is tracing the lineaments.

Yes, dear souls, simple souls, leave to God what belongs to Him and remain loving and passive under His action. Hold for certain that what happens to you internally and externally is for the best. Leave

God to act and abandon yourselves to Him. Let the
point of the knife and the needle work. Let the brush
of the Master cover you with a variety of colours
which seem only to disfigure the canvas of your soul.
Correspond with all these Divine operations by the
uniform and simple disposition of a complete self-
abandonment, self-forgetfulness and application to
your duty. Keep to the line of your own advance and,
without knowing the map of the country or the details,
names and directions of the land you are passing
through, walk blindly along that line and everything
will be indicated to you if you remain passive. Seek
only the Kingdom of God and His justice in love
and obedience and all the rest will be given you.

One sees many souls who are disturbed and ask :
Who will give us holiness, perfection, mortification,
direction ? Let them hunt up in books the precise
terms and qualities of this wonderful business, ' its
nature and parts ; as for you, remain in peace in
the unity of God by your love and walk blindly in
the clear straight path of your obligations. The
angels are at your side in this night and their hands
make a barrier round you. If God wishes more
from you His inspiration will make you know it.

DIRECT ACTS

Q. Could you explain to me by comparisons from
the senses what Bossuet said regarding the acts of
mystical prayer, which he calls direct and non-
reflective acts, which are little if at all understood,
practised in the heart and not signified, that is not
formulated in the heart in a reflective manner and
still less outwardly expressed by words, signs or exterior
acts ?

A. He wished us to understand by these words that
in the prayer of the simple presence of God and loving

attention to that presence, a soul finds itself in much the same attitude towards God, by a supernatural attraction, as that of any person who loves another by natural attraction when he is thinking of his beloved. In fact, is not all that he says about direct acts found and easily comprehensible in the heart of a mother thinking of her beloved child ? for while she is thinking these sweet thoughts does she not exert maternal love ? By direct acts which are merely simple interior movements, of a simple turning of the heart towards the child ; (ii) by non-reflective acts, for she does not reflect if she loves ; (iii) by acts confusedly if at all perceived, for she does not know them except by consciousness, so to speak, that is by a confused feeling she experiences without any attempt to disentangle what is passing within herself ; (iv) by acts which are not signified, since she says neither with her mouth nor inwardly in her heart : *I love this child very much ;* but she loves it none the less by means of acts performed in her heart ; she loves without saying anything, but merely by loving ; and if this child penetrated as God does into the heart of its mother, would it not see all her actual tenderness for it ? Nevertheless, while not reflected upon, these acts are so deliberate, so freely accepted and willed, that if the object of them was criminal that mother would be sinning, and would not fail later to accuse herself in confession of having passed a considerable time in a voluntarily criminal disposition of the mind and heart ; finally, may we not say of these acts that since reflection has no part in them they are all the more simple, natural, and sincere, and truly heart-felt, as Bossuet explains when writing of direct and deliberate acts which tend towards God ?

Q. What does Bossuet mean when he says : ' When the will is fixed on God it produces a succession of good movements, which in this life are called perpetual prayer ' ?

A. He wishes us to understand that there takes place in this good will towards God what takes place towards evil in a perverted will which produces a succession of thoughts, affections, desires, hopes, joys, fears, sadnesses, and other simple, deliberate criminal movements. Now is it not certain that God sees the good dispositions of the heart as clearly as the bad ones, and that He is even more ready to reward the good than to punish the wicked ? This is what caused our Bishops to say, in Article XIX of Issy, that ' perpetual prayer does not consist in a perpetual and single act, which one may imagine going on without interruption and which must not be repeated, but in a habitual and perpetual disposition and preparation to do nothing which might displease God, and to do everything to please Him.' For how many good movements either for avoiding evil or for doing good must be produced by this habitual and perpetual condition ?

Q. What, lastly, does he mean when he says that in mystical prayer we come to speak only the pure language of the heart, and that until this stage we speak to ourselves only in a human tongue, clothing our thoughts in the language we would use in explaining them to another ; but in contemplation, in pure recollection we *come*, he adds, *to speak so much to God that we have now no other language than that which He alone understands*, and which is that which we called the language of the heart ?

A. He means that the pure language of the heart does not and cannot express itself save by simple movements, by interior cries as St. Paul says, by groanings, by indescribable desires, even in the case of him who raises them to Heaven independently of all expression. For human words could but weakly express the feelings of a heart that has been deeply touched. Men themselves cannot do this in ordinary human intercourse, for when they have tried to bear witness to their mutual feelings, their reciprocal friendship,

they say : ' I wish you could see the feelings in my heart ' ; now that which men cannot express or see to their liking, God sees and understands : how shall I say it ? He understands, as the Prophet says, to the very preparation of our hearts ; that is, *the first movement of a heart which begins to will to set itself in motion in order to form a desire,* as Bossuet so finely says.

LISTENING TO GOD

CAUSSADE shows how the purified soul becomes habituated little by little by certain words in prayer to a simpler and quieter form of it.

Q. Why must we interrupt our discourse at intervals by attentive pauses ?

A. To listen to God in silence when we have spoken to Him, for He speaks in His turn during prayer, which is merely a dialogue, a conversation with God.

Q. How does God speak then ?

A. In many ways. For sometimes He speaks by visions, by revelations, by the interior words that we hear at the bottom of our soul, as St. Teresa says, as if they were formed and pronounced in our ears ; but this is not relevant now, for we speak only of simple ordinary recollection. God speaks through certain lights and inspirations, and therefore to make ourselves more attentive we must cease our own discourse from time to time. God acts when He speaks, for in God to speak and to act are the same thing : *Dixit et facta sunt.* He spoke, and everything was made, says Scripture :[1] we must, therefore, sometimes pause to receive the impressions God wishes to make on our hearts, which He moves, uses and handles, which He moulds as He thinks fit, in a truly incomprehensible manner, but much more easily than the cleverest hand could mould

[1] ' When our Lord speaks, it is at once word and work.'

to its will a piece of soft wax ; that is, provided that the impurities of the soul do not put obstacles in the way of His holy operations. God speaks, too, in giving what we ask, as the rich man speaks and replies in giving alms to the poor. We, then, must imitate the poor, who do not cry and groan without ceasing, but pause from time to time to stretch forth and open the hand in which they are to receive alms ; let us in the same way pause at intervals and suspend our cries, to give room for our desires and our confidence in being able to stretch forth or open the heart into which God, by His Divine infusions, should make to run both gently and secretly the firmly hoped-for and patiently awaited graces.

Q. During these intervals given to interior silence and attentive pauses, what does our soul do ?

A. It ceases discourse and reflections by a free act which suspends them ; and, by another act, or rather by the same, it rests in an attentive silence, rather like a man who, believing himself on the point of hearing a beautiful symphony, suddenly stops and suspends as much as he can all his other reflections and sensible movements, to make himself alert and give more attention to what he wishes to hear without losing anything of it.

Q. How long should these attentive pauses last ?

A. For a longer or shorter time, according to the circumstances ; for beginners, who have not yet acquired any skill in holding themselves in peace and silence before God, should make them short ; but later they gradually become easier and longer, either through their acquired dispositions, or by the beginning of some sort of attraction towards recollection ; from which we should conclude on the whole that we should rest in silence and listening every time, and for so long as we actually feel some good disposition of the spirit or the heart towards God.

Q. Could you give me some idea of these actual

good dispositions in connection with various kinds of prayer ?

A. Regarding those who pray vocally with the proper attention, or meditate, or perform reflective readings in the form of meditations, pious sentiments of fear, love, regret for the past or desire to live more nobly will on occasion occur ; now what prevents them from giving themselves up to these simple movements, from pausing to give themselves leisure to penetrate to the bottom of the soul, or to allow the Holy Spirit to impress them ever more deeply ? This is why the Church calls the latter *the finger of the Father's right hand.* Then, if there is need of a new stimulus to similar feelings, when they are stimulated a second time or several times by the same or similar reflections, what prevents them from acting in the same fashion, trying always to preserve as long as they can all these simple but salutary impressions, all these actual good dispositions which form recollection ?

Q. In what do these actual good dispositions of those whose prayer is completely affective consist ?

A. Sometimes in a certain inclination towards God, a desire to unite with Him, a simple tending of the heart toward God, a profound interior calm ; a magic peace which one does not usually enjoy ; which shows, say the mystics, that God speaks in His own way, that is, that He effects both peace and love at the bottom of the heart ; what prevents the soul from resting in this peace, in silence, in pure abandonment before God like the statue of which St. Francis de Sales speaks, or like a canvas hanging before the painter, according to St. John of the Cross' expression, that is without movement, without interior commotion, stopping its ordinary action, content to rest tranquil in an entire surrender of its whole self in the hands of God.